MW01282620

JOHN
LAURIS
JENSEN

C.D. 3924
COSTUME DESIGNER

SIGNATURE

HOLLYWOOD SKETCHBOOK

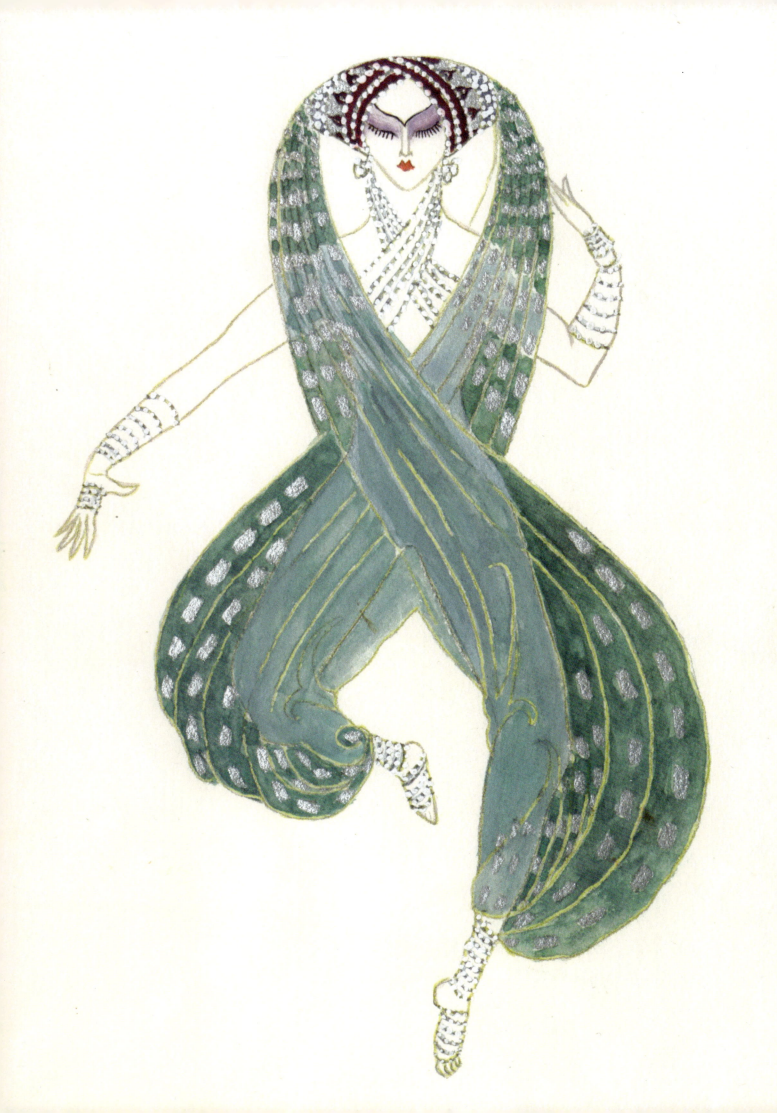

HOLLYWOOD SKETCHBOOK

A Century of Costume Illustration

Deborah Nadoolman Landis

An Imprint of HarperCollins Publishers

For Theadora Van Runkle, who I miss every day.
And for David C. Copley, who makes all of this possible.

HOLLYWOOD SKETCHBOOK
Copyright © 2012 Deborah Nadoolman Landis

All rights reserved. No part of this book may be used or reproduced
in any manner whatsoever without written permission except in
the case of brief quotations embodied in critical articles and reviews.
For information address Harper Design, 10 East 53rd Street,
New York, NY 10022.

HarperCollins books may be purchased for educational, business,
or sales promotional use. For information please write: Special Markets
Department, HarperCollins*Publishers*, 10 East 53rd Street, New York, NY 10022.

First published in 2012 by:
Harper Design
An *Imprint of* HarperCollins*Publishers*
10 East 53rd Street
New York, NY 10022
Tel: (212) 207–7000
Fax: (212) 207–7654
harperdesign@harpercollins.com
www.harpercollins.com

Distributed throughout the world by:
HarperCollins*Publishers*
10 East 53rd Street
New York, NY 10022
Fax: (212) 207–7654

ISBN 978-0-06-198496-9
Library of Congress Cataloguing-in-Publication Data is available upon request.

Book design by Agnieszka Stachowicz

Printed in Italy
First Printing, 2012

ALSO BY DEBORAH NADOOLMAN LANDIS

Dressed: A Century of Hollywood Costume Design
(as author)

Filmcraft: Costume Design
(as editor)

Hollywood Costume
(as editor)

Screencraft: Costume Design
(as editor)

50 Designers/50 Costumes: Concept to Character
(as editor)

Mame on the boulevard

black. taupe espresso mohair Rodier
"faux fur" wool print

black silk dress beneath

silk turban beaded veil
draped by Theadora on
buckram shape "mad hatter"

CONTENTS

INTRODUCTION	9
Eleanor Abbey	64
Adrian	70
Milo Anderson	82
Waldo Angelo	86
Pauline Annon	88
Adele Balkan	100
Travis Banton	102
Cecil Beaton	112
Marjorie Best	122
Phillip Boutte Jr.	128
Pat Carey	132
Bonnie Cashin	134
Christian Cordella	146
Joe De Yong	150
Donfeld	162
Virginia Fisher	180
Gina Flanagan	190
Charlotte Flemming	196
Jacques Fonteray	212
Haleen Holt	226
René Hubert	230
Dorothy Jeakins	242
John L. Jensen	258
Elois Jenssen	266
Robert Kalloch	268
E.J. Krisor	270
Mitchell Leisen	272
Charles LeMaire	274
Judianna Makovsky	284
Oksana Nedavniaya	286
Vittorio Nino Novarese	290
Mary Ann Nyberg	298
Orry-Kelly	302
Gabriella Pescucci	312
Walter Plunkett	316
Anthony Powell	328
Jamie Rama	342
Natacha Rambova	346
Leah Rhodes	356
Robin Richesson	360
Ann Roth	370
May Routh	382
Felipe Sanchez	396
Emile Santiago	404
Walter Schulze-Mittendorff	408
Irene Sharaff	410
Gile Steele	422
Edward Stevenson	432
Piero Tosi	442
Travilla	464
Dolly Tree	476
Brian Valenzuela	478
Valles	482
Theadora Van Runkle	486
Gwen Wakeling	514
Tony Walton	518
Julie Weiss	528
Clare West	538
Vera West	546
Mary Wills	548
Susan Zarate	562
THE RESEARCH ODYSSEY	566
FILMOGRAPHIES	574
BIBLIOGRAPHY	586
CREDITS	594
ACKNOWLEDGMENTS	599

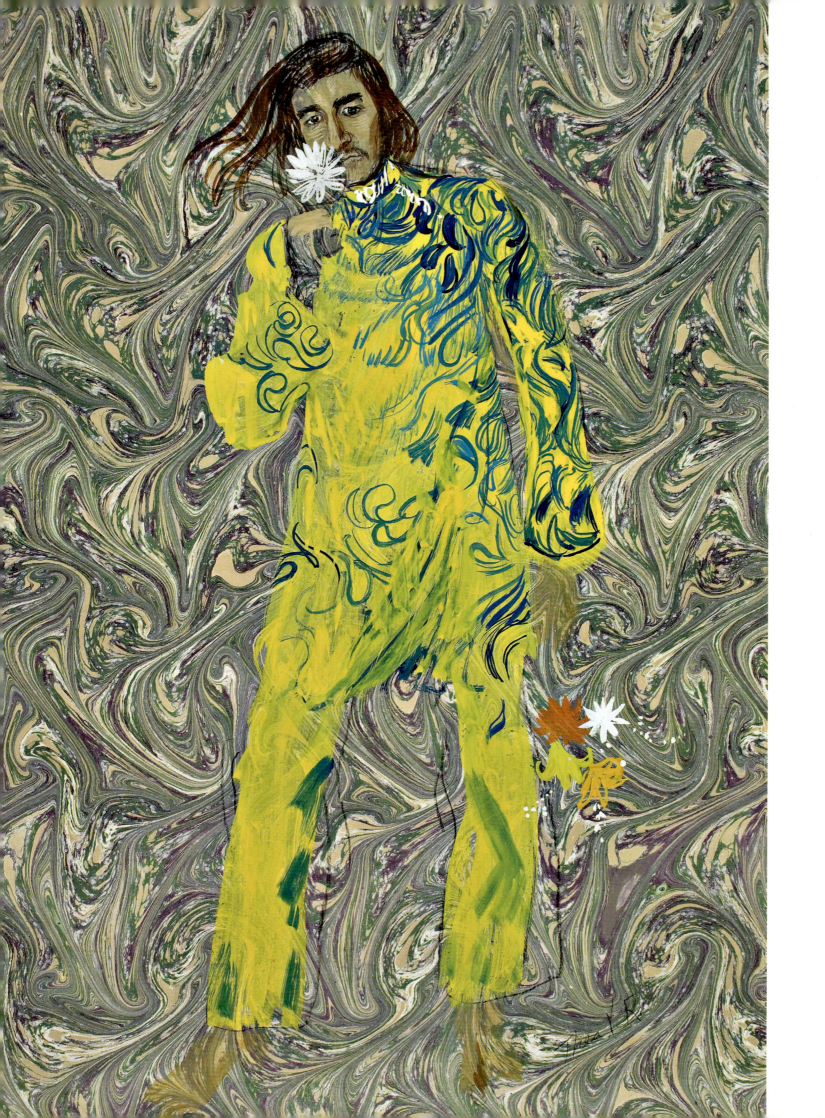

INTRODUCTION

A BEAUTIFUL COSTUME SKETCH DOES NOT MAKE A BEAUTIFUL COSTUME. I BECAME AWARE of this truth early in my career. When I was a stock girl at NBC Studios in the early 1970s—the heyday of television musical-variety shows—I witnessed the creation of hundreds of sketches made for lavish network productions. Often, I would admire a brilliant drawing posted on the corkboard in the costume workroom and then fret about my inability to match the talent of the artist. My own sketches never looked like professional drawings. Long-legged actresses and marvelous character studies eluded me somehow, and even with art and design training behind me, my drawings lacked style and authority. I was imaginative and my work was intelligent and witty, but my drawings were not. I tried not to be consumed by self-doubt. When I thought of sketching my designs, I was filled with the dread of discovery that I was a fraud. Clearly, I had no future as a costume designer.

Then a miracle happened: I noticed that sometimes the clothes on the dress form looked quite unlike the sketch. In fact, it happened that sometimes the two had almost nothing in common. The grace and glamour of the drawing had vanished. Sometimes elegance of the line had disappeared. All that was left on the dress form was a vulgar, earthbound interpretation of a germ of an idea expressed in the drawing. I recognized the garment as essentially the same dress represented on the sketch, but the costume fell short of its picture. Something terrible had occurred between the lines. Gone was the perfection of the drawing, and in its place was a clumsy copy. The drawing had captured the romance, the glamour, the movement, and the beating pulse of the character. A life existed on the paper but not on the dress form. Somehow, the light had been extinguished.

This contradiction always mystified me. A universe of variables exists for a designer between the completion of the sketch and the execution of the garment. A beautiful illustration does not exist for every beautiful dress. Taste and a great seamstress can make the difference between triumph and catastrophe. There are times when a costume looks like a mistake on the dress form when every choice was wrong and the result can be shocking. The symmetry of the garment may be unsound; the fabric, an error; the color, abysmal; the trim, uninspired and mundane. It's surprising that two-dimensional artistic skill and three-dimensional design—the ability to create a life-like character on paper and the sculptural dynamic of dressing a body—do not automatically coexist. A pretty picture is not tantamount to great costume design. The disconnect between two- and three-dimensional design can be confounding. More often it seems that more beautiful costumes have been made from imperfect drawings and a designer's tableside thumbnail. Ultimately, it's always the finished costume that counts.

PAGE 2: Costume designer and illustrator: Natacha Rambova. *Forbidden Fruit*, 1921. PAGE 6: Costume designer and illustrator: Theadora Van Runkle. *Mame*, 1974. OPPOSITE: Costume designer and illustrator: Theadora Van Runkle. *I Love You, Alice B. Toklas!*, 1968.

As my professional life evolved, I discovered that the beautifully rendered drawings that had eluded me were not what ultimately matter in costume design. I witnessed indifferent drawings become fabulous costumes, and inspired sketches give birth to ho-hum garments, and everything in between. While I was working at Universal Studios in 1977, Edith Head had a bungalow on the studio lot. Had I had the courage to discuss my angst with Miss Head, she would have set me straight. Miss Head was a famous stick-figure da Vinci, with an army of professional sketch artists ready to channel her designs into polished illustrations, to which she would boldly add her signature. Head's lack of skill with a paintbrush hardly hurt her career or her confidence. Her talent was design and public relations, and she did both brilliantly during a fifty-year career in Hollywood. (Ironically, it was not until I began my second career, as a historian, that I read Edith Head's marvelous writings regarding the contribution of costume design to storytelling. Her insights and passion for the work remain an inspiration.)

Nevertheless, my admiration for costume drawings and for costume illustrators grew throughout my career. Early on, I collaborated with my friend, fine artist Kelly Kimball, to illustrate my designs for *Animal House* (1978) and *Raiders of the Lost Ark* (1981). While our collaboration began in the late 1970s, we had met much earlier, during my time at NBC Studios. As a wardrobe stock girl, I was assigned to help Kelly, who was the master of the comedy costume. It was instantly clear that her adorable thumbnails were better than those of the famous freelance designers for whom she had helped to create the specialized costumes and fat suits for variety comedy skits. This fluency betrayed more than simple skill. Kelly's drawings were clever—wry remarks as pictures. They were a "gee, I wish I'd said that" kind of drawing with the punch of a *New Yorker* cartoon. Her talent and wit

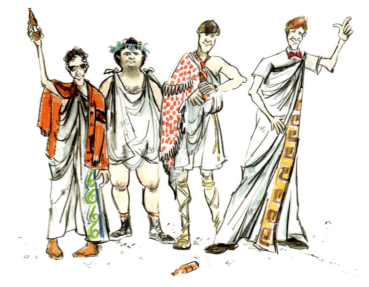

Costume designer: Deborah Nadoolman.
Costume illustrator: Kelly Kimball. *Animal House*, 1978.

were familial; a graduate of the famous Choinard Art School in Pasadena, she inherited that sly humor from her dad, legendary Walt Disney animator Ward Kimball. At NBC, Kelly and I were lucky to work on the last gasp of spectacular television variety shows such as the *Sonny & Cher Show* (1976-1977), the *Carol Burnett Show*, the *Flip Wilson Show*, and the *Captain & Tennille*, designed by costume showmen Bill Belew, Bill Hargate, Ret Turner, Pete Menefee, and the incomparable Bob Mackie. The clothes for these weekly musical shows were glamorous, but Kelly and I were definitely not. We got dirty, covered in glue and dye, and developed a close friendship. It was a lucky pairing in an unlikely setting. Kelly and I shared a wide community of artistic, textile, and horticultural interests. Our partnership felt predestined, and when I made the leap to designing feature films, it seemed natural that Kelly would be at my side. We stayed professionally linked for years and have remained close friends.

The motion picture is known as the great collaborative art form, and it has transformed from the producer's medium in the Golden Age of Hollywood into the director's medium today. Film production is so pressured by time and budget that streamlining communication with the key collaborators, whether through conversation, storyboards, or costume illustration, is ideal. Optimally, during their career filmmakers will gather a team of key collaborators, including a cinematographer, a production designer, and a costume designer. This trusted, close-knit group work together from film to film, establishing an indispensable shorthand to the director. Whether I was working with Steven Spielberg, Costa-Gavras, Louis Malle, or John Landis, each director was able to recognize my design and point of view in Kelly's drawings. There was never a question of artistic authorship; the directors expected me to fully realize the drawing as they saw it on the page.

Our loose and character-driven style was soon conjoined. As costume illustrator and costume designer, Kelly and I worked side by side, elbow to elbow, from movie to movie. Our conversations ebbed and flowed as did our creative process. Often, I would doodle a collar, a cuff, the outline of a woman's back, and buttons on a sketchpad to describe the vision in my head—everything except a fully realized painted figure. Or I would stand beside Kelly as she worked and say, "A little more like this, or that." Sometimes, when multiples or identical costumes were required, Kelly would create a chorus line of croquis (basic female shapes) for me to complete like a color-by-number exercise. This allowed me to work out basic garment shapes for an actor's many costume changes, but was not expressive of the personality of the character.

Kelly and I never confused the unique roles of costume designer and illustrator. The role of the costume designer is to fully realize, in three dimensions, the people in the screenplay, based on conversations with the director. Costume illustration is an intermediary step, an artistic response that is borne of that dialogue. There are many designers who use the drawing process to find the character, to play with the color palette, and to perfect the proportion and the cut of the clothes on paper. Theadora Van Runkle told me that she

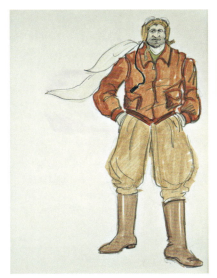 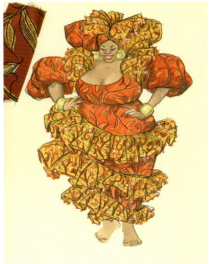 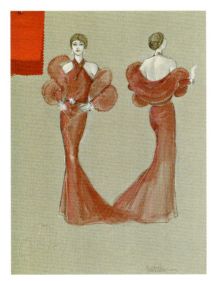

LEFT: Costume designer: Deborah Nadoolman. Costume illustrator: Kelly Kimball. *1941*, 1979.
MIDDLE: Costume designer: Deborah Nadoolman. Costume illustrator: Kelly Kimball. *Coming to America*, 1988.
RIGHT: Costume designer: Deborah Nadoolman. Costume illustrator: Kelly Kimball. *Oscar*, 1991.

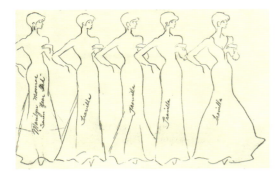

Croquis sample. Costume designer and illustrator: Travilla. *The Seven Year Itch*, 1955.

needed to draw to "see" the character. My creative process starts with research, continues with finding the right fabric, and follows by draping on the dress form. Handling the fabric and shopping for the trim are key. For me, drawings (combined with substantial research) help to illuminate the milieu of the entire movie and serve as a point of discussion with the director. Costume designers fall into these two groups (drawing and nondrawing), and both processes are of equal value.

After reading the deadpan comedy ¡*Three Amigos!* (1986), Kelly and I spent weeks researching the Hollywood studio culture (circa 1917) and the Mexican Revolution. Dressed as rhinestone-studded mariachis, Steve Martin, Martin Short, and Chevy Chase play silent movie heroes summoned to save a Mexican border village. For their nemesis, El Guapo (played by Alfonso Arau), and his despicable banditos, Kelly was able to evoke trail dust and the scent of cow dung in every sketch. Their malodorous fragrance virtually rises from the paper. Throughout our long association, spanning at least twelve feature films, Kelly generously supplied her extraordinary talent to make my work look so great.

This book reflects my passion for my profession and my admiration for my colleagues and our shared legacy. For my last book, *Dressed: A Century of Hollywood Costume Design* (2007), my research posse (supervised by my longtime assistant and amateur private investigator Natasha Rubin and comprised of many graduate students) and I searched for the Holy Grail: the ever-elusive superb costume sketch that matches the iconic star in the classic film still. This decade-long treasure hunt took us through archives, libraries, and private collections filled with anonymous costume sketches of unknown characters from undistinguished movies. My curiosity regarding these mostly forgotten drawings grew exponentially, coupled with my nostalgic memories of the decrepit (albeit romantic) Hollywood film studios from which they originated. Galleries of original artwork were

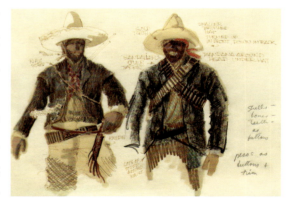

Costume designer: Deborah Nadoolman. Costume illustrator: Kelly Kimball. ¡*Three Amigos!*, 1986.

waiting to be discovered and admired by the public. These watercolor illustrations, mostly unframed, were preserved from the sunlight in their hiding places. At last, after decades of being thrown into dumpsters, stored in leaky sheds and garages, and hidden away in archives and private collections, more than five hundred costume illustrations from more than seventy-five designers are here to be discovered.

FROM SCRIPT TO SKETCH

Costume drawings can achieve a transparency and emotion that make them feel like fine art. They can be inspiring, romantic, and filled with wonder. Figures can be kinetic, alive with movement and dancing off the page. Unlike fashion drawings, which may also be fanciful, costume drawings are the manifesta-

tion of the character as written in the screenplay and conjured by the designer. We can read the personality of the character in each drawing. Through their clothes, their multiple accessories, their attitude, the shape of their figure, their posture, their hair and grooming, and the illustrator's talent at painting a scene, we know who they are. It is intuitive. These are clothes that never have to please a department store buyer or a fashion critic, parade down a runway, launch a trend, or attract a customer. They will not be reviewed or judged in *Women's Wear Daily*. And the designer will not go out of business if they don't sell. The costume designer has no label to stitch into the garment. Nevertheless, these costume drawings have a job to do.

Costumes exist because of the film. They work hard for the story, the director, and especially for the actor. They must completely disappear into the scene when the director requires it, or, paradoxically, stop the show. Costumes must provide an actor with the tools to become the most beautiful, the most hideous, or the most ordinary person on Earth. The product of significant conversations with the filmmaker, costume drawings animate a written character and produce a charismatic portrait based on the description and dialogue in the screenplay. They express the narrative by fully illustrating the *people* in the story, not just their clothes. The word *character*, with its fictional connotation, does not fully express the individuals that we hope to portray on screen. We seek to create believable people to fully engage the audience in their story. When the film starts, we join these diverse personalities at a moment in their lives. A collection of costume sketches from any film is the family album of the screenplay.

Costume sketch collector and author of *Adrian: Silver Screen to Custom Label* (2008), Christian Esquevin thoughtfully condensed the life of a drawing by saying, "A sketch can be viewed as a piece of art, but has deeper levels of meaning that you can peel like an onion. It was passed from hand to hand along the lines of the production until finally everything was finished and the sketch had no other value. It continues to be one of the physical treasures that remain from that long-ago period." Long before movies were popular entertainment, costume designers worked

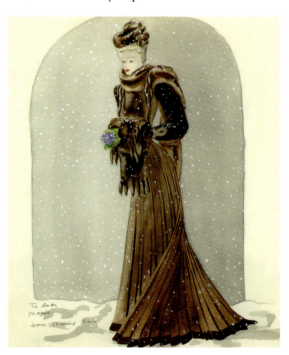

Costume designer and illustrator: Muriel King. *Back Street*, 1941.

for the stage and produced costume illustrations. These theatrical costume sketches and the sketches later produced for motion pictures play the same role in the costume process. A play or screenplay is read and digested by the creative team. At their first meeting, the director discusses the script and its characters with the costume designer. Ideal casting and possible actors will be suggested, and by the end of the first meeting the costume designer will have a pretty good idea of the challenges ahead. The director will also brief the cos-

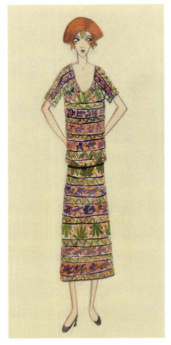

Costume designer and illustrator: Clare West. *Single Wives*, 1924.

tume designer on the setting (production design) and the mood (cinematography) of the narrative. This engagement between costume designer, director, and producer had been formalized long before the Golden Age of Hollywood. The earliest silent films are lush with costumes in every genre. Each director may have an idiosyncratic way of working, but the path to costuming a film remains basically the same from the early days of Hollywood. The producer, director, and costume designer must be in stylistic lockstep, and the initial conversations launch that relationship. Every choice the director makes defines the look of the film. Give the identical screenplay to five different directors and they will make five completely different films.

Sketches, costume illustrations, drawings, or "costume designs," as they are called in England, have always served as valuable and practical tools for the costume designer. The drawings—of one character per page or per board, or as part of a collage of photographic images and inspirations—may facilitate communication with the director and the creative team, which includes the production designer and cinematographer. The production designer and the art department are also responsible for creating a portfolio of production drawings for the director to approve. These, combined with the costume illustrations, represent the place and the people in the story and illuminate the world of the screenplay.

As chief designer at Paramount Pictures, Edith Head worked closely with director William Wyler. She reported that "when Willie Wyler makes a black-and-white picture, he wants only black-and-white sketches (we usually do all sketches in color). He is completely the realist." When recalling her experience designing *Roman Holiday* (1953) for Wyler, she said he insisted that "Audrey Hepburn had to look like an everyday girl." For Head's 1949 Oscar win, *The Heiress*, the director repeated his wish to keep his people real. He said, "Olivia de Havilland had to look as if no human being would marry her except for her money." Wyler was adamant that Head not overglamorize his stars and keep their ordinary characters authentic to the spirit of the screenplay. Head, following his orders, said, "There can be no fudging, no extra hint of softening."

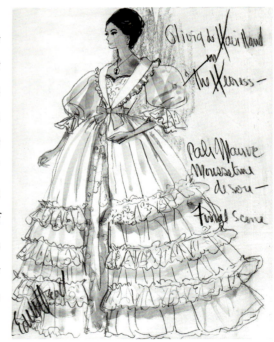

Costume designer: Edith Head. Costume illustrator: Pat Barto. *The Heiress*, 1949.

Wyler was just as specific regarding the style of Head's fashionably chic costume illustrations. Head noted, "He wants no model sketch, but a sketch that looks exactly like what he's going to see on screen, with the figure drawn like the figure of the actress." This was a refreshing exercise for the army of Hollywood sketch artists that Head usually employed. Head explained, "Normally, a designer sketches an elongated, stylized dream of a figure: tall, long-legged,

tiny-waisted, slim-hipped—a willowy clotheshorse." Wyler, she said, demanded that "if the actress is short and broad, draw her short and broad, and the dress as it will fit. He wants real women walking around in his mind's eye, and on his screen." Head's finished sketches for Wyler's films realized the real women in his story, not an idealized movie star in costume. The script, the ensuing conversation with the director, and the drawings were—and remain today—part of the development of the people who emerge from the story.

The costume designer's role is multilayered and encompasses a myriad of creative and organizational duties. These include the budgeting and scheduling to get the clothes onto the actors on time and on screen, with the help of the costume crew. The creative duties involve designing the costumes for the people in the script, and parts of the job may be unexpected such as supporting the composition of the frame by placing the dressed extras (with the second assistant director) in the foreground and background of the scene according to the color (neutral or bright) of their garments. This costume choreography helps the director create point perspective in the frame and fixes the audience's attention on the principal cast. The lead actors will always be in the foreground action because they will be telling the story.

The first step of any successful costume is for the designers to invent the physical presence of each person in the story, including their hair and makeup, from their top hat to tap shoes. For most costume designers, a defined period of research is the key. Designers often complain that there is little time in preproduction to internalize the research prior to drawing. Costumes develop from the script, to conversations with the director to research, and then on to the fitting room, and sometimes the sketch is not part of the process but acts as a bookend to the creative process. Sandy Powell has designed films in every genre, and her initial approach is always the same: "I would never start cold with a costume drawing," she says. "I begin by reading books and looking at visual references from the time. I compile huge reference books of images, some directly related, some just things that give me a certain feeling." Powell's rich life experience and her personal memories are on call for research as well. The people in films are often based on family, friends, and acquaintances of the screenwriters, directors, and designers. Powell's preferred process is to paint the character after the costume is completed.

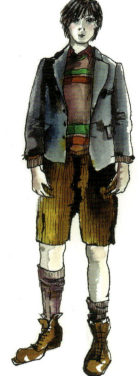

Costume designer and illustrator: Sandy Powell. *Hugo*, 2011.

Before the arrival of the actor, the physical manifestation of the character is based on the dialogue, dramatic clues in the script, the writer's descriptions, copious amounts of research, and multiple conversations with the director and costume designer. A rough sketch that is developed from those exchanges acts as a shorthand, a kind of blueprint and template. Although the realization of this vision is a challenge, a good designer excels at making choices. Sometimes it feels as though costumes "happen" without any intermediate steps, that the finished product is the result of an intuitive process. There are characters who reveal themselves at a moment in the design process through the discovery of a piece of vintage fabric, a hat, an umbrella, or a handbag. Designer's offices can be filled with inspiration such as bolts of fabric, massive research books, a

wall of artwork and photography, bits of jewelry, flowers, and more. This creative space provides the entire costume crew with a look inside the designer's brain. The synergy that happens between the illustrator and the designer can be electric or quite elusive. It is often the costume illustrator's sketches that coax the designer from conceptualization to an end design, with as little explanatory language as possible.

Often it is the designer's pencil sketches and rough drawings that establish a silhouette and shape for a character. Historically, tracing paper has been used to replicate an approved rough onto a final drawing. (Computer rendering has made this technique nearly obsolete.) Although most of these preliminary drawings were discarded as soon as the final drawings were finished, some tracing paper roughs from earlier eras still exist in archives. The currency of the costume designer is emblematic of the old entertainment-industry adage: Show, don't tell; when you can draw, don't describe. Legendary MGM costume designer Adrian illuminated his creative process in an early fan magazine interview when he said, "My first task is to make pencil sketches of costume ideas, only a silhouette, the 'body line' upon which the costume will be developed. Then the details of the neckline, the sleeve treatment, and trimmings are drawn in, and the costume is adapted as a whole. At this point, I work the pencil sketch out in watercolor in the approximate tones in which the costume will be made, with color contrast and details as they will appear in the finished costume." Notably, Adrian is remembered for the glamorous stars that he dressed, including Greta Garbo, Jean Harlow, and Joan Crawford, among many others. In his writing on costuming, Adrian takes pains to separate the merely fashionable from the character costume. Adrian produced thousands of sketches in his career, although very few have survived. With Adrian, British designer Oliver Messel designed the 1936 MGM version of *Romeo & Juliet*, starring Norma Shearer and Leslie Howard. It's reported that they created an astonishing 1,250 costume sketches for this production, the largest number for a film up to that time. Adrian's rough pencil sketches, like those drawings created by designers today, were the first snapshots of a character in the movie. When the drawings were completed, Adrian filled the closet of each distinct personality in the screenplay and created an album of characters whose costumes set the people, place, and time in the narrative arc of the story.

Drawings may require extensive revision after careful review by the director, whose style sets the look and feel of every film. The director chooses everything in the movie, both directly and indirectly—from the location to the color of the automobile upholstery to the clothes in the characters' closets. Whether the director is Quentin Tarantino or Alfred Hitchcock, stories about the convergence of directing and design emerge from each Hollywood era. Actress Doris Day shared this anecdote about *The Man Who Knew Too Much* (1956): "The first time I saw Hitchcock, I was with Edith Head, talking about my costumes. Hitchcock came in,

Costume designer and illustrator: Leah Rhodes. Unidentified film.

wanting to see the sketches and to discuss them; he is a very thorough man who gets involved in every aspect of a picture he's doing. On that day, he threw out some of Edith's sketches and was very precise about exactly what he wanted for my wardrobe. Hitch's office on the Paramount lot was right next to wardrobe, so he'd often drop in during my fittings to keep an eye on just what they were creating for me." Hitchcock's screenplay would have looked radically differently through the eyes of Head's other director, William Wyler, who was equally specific about the look he wanted from his costume designers.

It is up to the costume designer to determine whether or not to hire a costume illustrator when starting a new project. Among the factors driving this decision are the size of the cast and the production, and the length of the preproduction and production schedule. On modestly budgeted modern films, hiring a costume illustrator is out of the question. Designers may decide to do (or not do) their own drawings and/or assemble mood boards, which include picture collages of drawings, research, and inspiration. On larger motion picture projects of every genre and period, including modern films, the designer may have the opportunity to hire a costume illustrator—or a team of illustrators—for the length of preproduction and, in rare cases, for the length of the production. Costume illustrators typically work part-time on any film and are hired on an as-need basis.

Costume designer Isis Mussenden was embarking upon the major creative adventure of *The Chronicles of Narnia: The Lion, the Witch, and the Wardrobe* (2005), the first of the Narnia fantasy trilogy, when she met her illustrator, Oksana Nedavniaya. Both were attending a costume illustrators' panel at Comic-Con in 2006, the annual comic book convention in San Diego. Mussenden was impressed that "Oksana's sketches were rich with color and texture. Her renderings had a sophistication that was quite striking considering we were in the middle of Comic-Con, where everything is pulp." Nedavniaya and Mussenden were in sync,

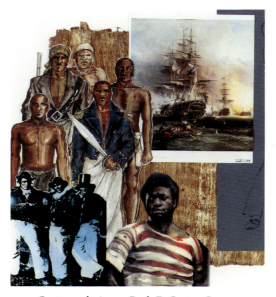

Costume designer: Ruth E. Carter. Costume illustrator: Gina Flanagan. *Amistad,* 1997.

Nedavniaya explains: "We look at different research images and then talk about the concepts, fabrics, and details. Isis provides me with a rough pencil sketch, usually with tons of notes, which are really helpful when I sit down at the drawing table. My next step is a preliminary pencil sketch, which might need reworking after another conversation with Isis. Once that drawing is approved, I will move on to watercolor." Nedavniaya partnered with Mussenden on *The Chronicles of Narnia: Prince Caspian* (2008) for nine months, at first developing early concept sketches for the entire cast. They delivered approximately one hundred costume sketches to the studio, the producer, and the director for approval during the course of this major production. This is an extraordinary number of costume drawings for any past or present film and is quite rare in the industry today. Some designers may never require the services of a costume illustrator during their career. When a costume designer is an accomplished draftsman, fully capable of producing immaculate and emo-

tive drawings, using a costume illustrator may be a foreign concept. Anthony Powell, for example, prefers to draw his own designs. Powell says, "For me, the process of drawing is getting to know the characters intimately and putting oneself in their place so that one knows them from the inside. You can make yourself feel how that person can stand, and [how they] hold themselves, their body language." Powell is not unique among those designers for whom the character arrives during the process of drawing; Theadora Van Runkle and Ann Roth have expressed a similar sentiment.

When the screenplay provides a rich visual landscape, the designer may yearn to produce a large portfolio of illustrations, but the intense scheduling of designing, costume fittings, and shooting will successfully sabotage even the most organized designer's day. Drawings must be created, approved, and ferried to the cutter-fitter to begin production on the clothes. Regardless of their drawing skill and speed, designers will often need to depend upon an illustrator who can express their ideas completely and quickly to keep the costume production cycle moving.

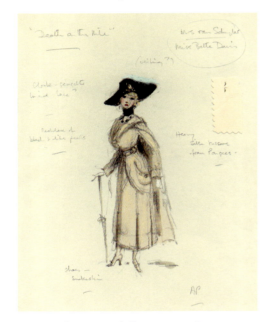

Costume designer and illustrator: Anthony Powell. *Death on the Nile,* 1978.

Relationships within the tight-knit costume team can suffer from the pressure of the preproduction schedule, and they can range from collegial to tense on any day. Historically, the role of the illustrator runs the gamut from those who act as a public letter writer—literally taking the designer's dictation—to those who become collaborative creative peers acting (by default or agreement) as an assistant or associate designer. Unfortunately, stories abound of insecure designers who have hidden their illustrators in office closets, pretending to the world—and the rest of the production—that they didn't exist. More than one designer has taken credit for a drawing produced by an illustrator's hand because it was simpler to do so rather than explain the role of an illustrator. Many more designers have showcased the artwork of their illustrators with great pride, confident that the design of the costumes is truly their own.

Western Costume research librarian Bobi Garland has observed, "People (and not just people from outside the industry) get confused if a designer doesn't do their own sketches. They think that they haven't really designed the costume. There are times that designers become sensitive because they feel that the sketch artist tried to take credit for an idea. Sometimes, the sketch artist is asking just for credit for the sketch, but the designer feels that they're asking for credit for the design." For the relationship between the costume designer and the illustrator to run smoothly, each must understand the parameters and nuances of their role in the creative process and the authorship of the design and the drawing. Because film production is so intense over a short period of time, a costume crew must be a neutral blend of complementary personalities that work well together under extreme pressure.

Illustrators are a tremendous boon to a costume designer when rapid changes to the shooting schedule are unavoidable. Flexibility, responsiveness, and resourcefulness define the veteran designer. Avoiding catastrophe and dodging bullets are occupational hazards. Films are shot out of continuity (individual scenes are not filmed in the order they occur in the script), and new drawings must often be created throughout the production schedule. Unforeseeable "disasters" are guaranteed to occur between the time a costume illustration is produced in preproduction and when the actual costume is needed (perhaps months later) in the shooting schedule. New characters and/or new scenes may be added or deleted as the film is being shot. It is inevitable that casting, especially of secondary roles, will occur late in preproduction. Due to actors' scheduling conflicts, even the principal roles may not be cast until the very last minute. Costume designers bear the brunt of this inconvenience, typically having designed the costumes with the director's approval long before most actors' definitive involvement and their contract is signed. Other than the major stars who are attached to a project, casting is not necessarily set in stone. Often, a last-minute piece of casting or a character change requires a total reimagining of the design. A role written for a male may be changed to female, one famous Hollywood blonde substituted for another, or a blonde to a Bollywood brunette, a Caucasian to an African American and back again. This kind of excitement is a regular occurrence.

Costume illustrator Robin Richesson was working on director Robert Zemeckis's *Contact* (1997) with costume designer Joanna Johnston. "We were just about to start shooting when Jamie Lee Curtis, who was supposed to play the secretary of state, dropped out at the last minute because her deal fell through," Richesson recalls. "Curtis was immediately replaced by [African American actress] Angela Bassett. Of course, all of the sketches looked like Jamie Lee Curtis. Joanna wanted to show Angela the suits that she was going to be making for this character, pencil skirts and 1940s-influenced jackets. Naturally, I had to immediately repaint the faces and body in the sketches to look like Angela Bassett. We didn't have time to redo all these sketches because all this happened at the last minute. I could have made them look much more like Angela had I been starting from scratch, and unfortunately, I was not working digital at that time." Computer rendering would have been helpful to Richesson and Johnston, allowing for an easy shade and color replacement instead of the time Richesson spent laboriously repainting her sketches for Johnston's creative meeting with Angela Bassett about her costumes.

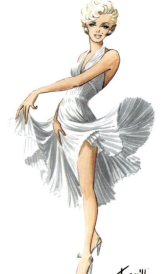

Costume designer and illustrator: Travilla. *The Seven Year Itch*, 1955.

A sudden change of cast is only one of a dozen reasons that the costume illustration may not marry with the final design of the finished costume. The drawing may be simplified when the film's budget shrinks or embellished when it expands, the concept for the character may shift up or down economically, the ideal fabric may not be available, the color of the set or palette may be refined, a dress may be lengthened or shortened, the actress prefers sleeves to sleeveless, the weather turns hot or cold or rainy, the time period of the movie may advance or retreat, and

the genre may waffle. This is a small sample of the critical variables that can alter a costume concept between the sketch and the screen. Because of the unpredictable nature of film production, it is common for costume illustrations to differ from the final costume seen in the movie. When the actor's pose in a promotional still or a frame capture seems to be mirrored in the drawing, it is most likely that the sketch was produced after the film was completed. This is a traditional custom and practice in Hollywood where designers were often asked to produce sketches for publicity releases and press kits.

In preproduction, the costume designer will attend multiple production meetings and work on budgeting with the costume supervisor (the administrative head of the costume department). The costume designer must meet the actors and discuss the costumes with the cutter-fitter and the costume workroom. Later, the designer must swatch fabrics, approve the buttons and trim, and still later, critique and approve the toile, or muslin patterns, of the costumes.

Costume designer and illustrator: Daniel Orlandi. *Down With Love*, 2003.

After a careful reading of the screenplay and one or many conversations with the director, the designer and the costume illustrator begin to create initial sketches. A multiplicity of drawings and a distinctive palette are often created for a character as they progress through the dramatic arc of the story. The number of drawings created for a film can be overwhelming. Theadora Van Runkle created a separate portfolio for each film in her distinguished career. She said, "It took a lot out of me to do those illustrations. I worked long hours getting the things manufactured and long hours fitting the actors and would often be very, very tired. Now I think that I should have just gone through magazines and books and put them all together in a collage in a week's time with rubber cement and mounting board. Then they [director, producer, actors] could say, 'Yeah, that's exactly what I had in mind!'"

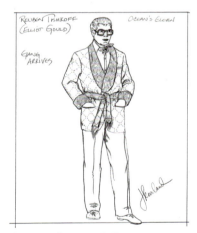

Costume designer: Jeffrey Kurland. Costume illustrators: Haleen Holt and Jeffrey Kurland. *Ocean's Eleven*, 2001.

During his long and illustrious career, which includes fourteen films with director Woody Allen, Jeffrey Kurland has had many opportunities to design and create modern clothes for the screen. This has not deterred him from drawing, designing, and manufacturing contemporary clothes for a movie. As he describes, on *Ocean's Eleven* (2001), his "mandate from the director, Steven Soderbergh, was 'not reality, but a heightened reality.' It was a new world that we were creating where the boundaries are endless. You can draw and create exactly what would be perfect for the piece—from the mind to the paper to the reality of fabric. The whole point of doing all of this is to tell an individual story in an original way. If directors allow themselves to go there, it makes for a more interesting piece." Sketches do not "just" describe the clothes. The director will not expect a finished-looking garment in the drawing, but a fully illuminated and idiosyncratic individual. Jeffrey uses

a combination of techniques to produce sketches. He enjoys drawing when he has the luxury to do so and also hires illustrators when his time at the drawing table is limited.

After the design has been approved by the director (and sometimes the producer and actor), the designer will deliver the sketch to the seamstress, tailor, or master cutter-fitter. At this point, the illustrator's work is complete, and the costume will now be interpreted in three dimensions by the cutter-fitter. The sketch and the designer arrive at the costume workroom at the same time. Retired Warner Bros. costume department chief and longtime cutter-fitter Catena Passalacqua explains the customary path: "The sketches were all signed and approved before we got them in the workroom, by the producer, the director, but not the actress. The sketch went to the seamstress from the 'head lady.' That table lady would put the toile together on the figure, and then the designer would okay it and keep going on from there." These artisans are interpreters.

Costume designer and illustrator: Irene Sharaff. *The King and I*, 1956.

Costumes are inevitably improved by the "table lady" on the cutting table in the costume shop. Cutter-fitters are enormously creative; their suggestion of a slight but integral move of a shoulder seam, for example, may transform the fit and silhouette of a costume. It can be said that a designer is only as good as his cutter. Designers depend on skilled artisans to realize their vision, and wise designers give them the creative freedom to improve upon it. Understandably, it can be daunting to realize the two-dimensional illustration into a three-dimensional costume. Design additions, alterations, and other addenda are usually noted with drawings and text directly on the sketch. If the sketch is a map, these are the directions to the front door. Arrows, random words, and minutiae describe the exact place where the shoulder seam meets the sleeve, the lace detail on the hem, and the critical location of the vest pocket. Accessories, jewelry, shoes, and hairstyles are also often added. Passalacqua often adjusted and enhanced the garment with the designer's permission: "If there should be a change, on the back of the drawing you'd see an arm showing that the sleeve should be different. The designer would say, 'Oh, well let's do it this way.'"

Designers spend considerable time working on the dress form and at the cutting table. Passalacqua nurtured many designer relationships throughout her long career; her favorites included Donfeld and Howard Shoup. Hundreds of sketches landed on her cutting table. She became close friends with designers because she was generous with her talent and her communication style was direct: "Designers would sit down and talk with you about the design. If they wanted a change, I would say, 'Make notes on it.'" Often, clarity is needed when sketches are so stylized or impressionistic that the cutter-fitter is unclear about the construction. Donfeld became her close friend, but his sketches are highly stylized,

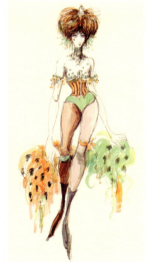

Costume designer and illustrator: Donfeld. *The Great Race*, 1965.

featuring elongated figures. Passalacqua said, "You had to figure them out for yourself. Donfeld's sketches are beautiful, but the people in his drawings are, like him, all drawn like 6'4". When you get a little actor, where are you going to put the buttons and the zippers? How are you going to get the actor in and out of the clothes? Designers don't tell you where to put the zipper, and they don't tell you how many buttons are going to fit if the actor is short-waisted and there's no room for six buttons even if the designer has drawn six buttons. Once I worked it all out, I would definitely have Donfeld okay the toile."

Novelists often claim that their "characters write themselves." In the world of the costume designer, the characters in the film emerge after an intense and (what should be) joyful collaborative process. A costume designer shares authorship with a team of talent in the costume department. On big budget films, this may include an army of cutter-fitters, milliners, agers, dyers, weavers, shoemakers, glove makers, armorers, textile artists, knitters, prop makers, and concurrently, the wigmakers and makeup artists. The costume designer will arrive to each meeting with a visual reference and/or the costume illustration in hand. It is this key image that launches the creative conversation. The resulting choices may diverge greatly from the original costume reference material. Inevitably, these master artisans make a major contribution to the look of the final film.

The overall design of a movie has a discrete color palette that is established by the director with the collaboration of the key creative team: the cinematographer, production designer, and costume designer. Production drawings, storyboards, and costume sketches provide the focus for communication, when the pressure cooker of film production allows those departments time to consult. Costume sketches elicit immediate intuitive responses more effectively than a rushed brokered conversation with the director about the intent of the screenplay. With a contracted preproduction, there is often no time to complete a set of original drawings for principal characters. Designers must use the visual reference materials at hand. One designer whose work has the authenticity and power of outsider art, Julie Weiss, is compelled by color: "You swatch anything you can to get that right color. If I was sitting in a subway and I needed a color, it would be all I could do to not cut a little bit off somebody—what they had on right in front of me. If it's getting to that time and you need the color, you'll do anything to get it."

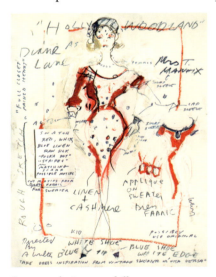

Costume designer and illustrator: Julie Weiss. *Hollywoodland*, 2006.

Color palette and a defined silhouette are ways that film designers signal visual commonality to the audience. Replication of style throughout a film is an effective theatrical device to help the audience recognize each protagonist. If the character wears dresses with a round neckline, it is likely that the designer will continue that neckline on her throughout the film. Personal taste and strict adherence to a color help establish a genuine identity for each personality. In any group of principal sketches, each character will have one "look," color, and silhouette, and this will be very obvious. In the final film, this design conceit will be invisible to the audience.

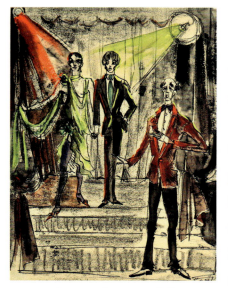

Costume designer and illustrator: Charlotte Flemming. *The Serpent's Egg*, 1977.

The use of this design protocol enables the audience to instantly recognize the character when they make their entrance into the frame.

Drawings can take any shape and form, and there is a playful tension between drawing styles throughout this volume. Julie Weiss's ravishing graffiti portraits are covered with blank verse. Bonnie Cashin's drawings retain the look of formal fashion illustration, but they are alive with a wit and a humor that surpass commercial fashion material of the 1940s and early 1950s. René Hubert's deceptively primitive watercolors of movie star gowns are charming children's book illustrations in search of a fairy tale, starring Lana Turner. Designers may incorporate props, pets, drapery, and interiors into a sketch, like the hard-edged *Cabaret* (1972) cartoons of Charlotte Flemming, which include complete vignettes of bordellos and nightclubs, placing singer Sally Bowles into the milieu and the context of the scene. Designers and illustrators may change drawing styles over the course of their careers, like Warner Bros. costume chief Orry-Kelly who started with Art Deco line drawings that looked like Bette Davis and ended with brushed paintings resembling fine art. Designers may change styles with every new production, like the gifted Theadora Van Runkle who drew into the genre of the screenplay using a trope like "psychedelic" for her sketches for *I Love You, Alice B. Toklas* (1968), or retain the same sinuous style throughout their career, like Donfeld, the Hollywood El Greco. Anthony Powell keeps aesthetic time to the melody of the piece. Powell says, "The whole business of making one's drawings convey the mood of the project dictates one's choice of medium and style. Light and delicate pencil or charcoal with washes of transparent watercolor for comedy, or darker paper and heavier gouache for drama, for instance." Sometimes, a designer and illustrator attempt a likeness of an actress using watercolor, or the favorite nowadays, Photoshop. In the early 1930s, Orry-Kelly was tipped that he was much more likely to get the job designing at Warner Bros. if he could flatter their biggest star and sophisticated clothes horse, Kay Francis, with a glamorous likeness. He prepared a portfolio selection just for her and was rewarded with the position, which he held for decades. Ironically, when Kelly was the busy chief designer, he often drew (in haste) perfectly rendered gowns as headless figures.

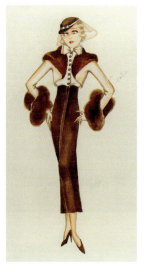

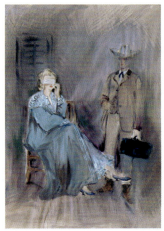

TOP: Costume designer and illustrator: Orry-Kelly. *Fashions of 1934*, 1934. BOTTOM: Costume designer and illustrator: Orry-Kelly. *The Hanging Tree*, 1959.

Costume designer Sandy Powell finds that a strong resemblance to the actor propels the character. "I often start by doing an absolutely accurate tracing of the actor's face from a photograph (preferably taken by myself and not retouched), then I mark it up to conform to the character being represented, which often

involves modifying or changing features with makeup and working out suitable hairstyles and facial hair. When I know who that person is, the ideas about what happens below the neck begin to flow." When working with costume designer Catherine Martin for *Moulin Rouge!* (2001), codesigner Angus Strathie dug deep in his digital toolbox to make certain that Nicole Kidman was present in the sketch. Many directors have a difficult time envisioning the actor in the gown and Baz Luhrmann was no different. Strathie confides, "Even my costume sketches couldn't just have a generic face, because Baz can't look at a drawing unless it looks exactly like the person who will be wearing the frock!"

In the past, a verisimilitude or resemblance was all that was required to imagine the character and the costume on the actor. Many costume sketches utilize a haiku for facial features, leaving detailed drawing for the clothing from the shoulders down as a close description of the costume. It has always been crucial that a drawing conveys a feeling about the person in the story rather than an exact likeness of an actor. There have been occasions when directors have been completely blindsided, when the person on the paper is not who they had envisioned after long initial meetings with the costume designer. This thorny professional problem is complicated further if the director cannot fully articulate his or her vision to the key collaborators, including the costume designer. The success of the costume sketch lies often in the director's ability to intuit the meaning of the drawing. Whether or not the drawing itself resonates with the director is not necessarily within the designer's control. This is a multilayered, interpretive process that a few directors have failed to grasp. Theadora Van Runkle has had some experience in this area. She groaned, "Some people can read a sketch and some people can't. They can read a contract, but they can't read a sketch." Longtime Woody Allen collaborator, production designer, and costume designer Santo Loquasto remembered that "sketches made Woody nervous. Woody thought that costume sketches were pretty and fun, but he preferred Xeroxes of the research of the blouse or hat. He just wanted the security of knowing it wouldn't look like a musical. It was fascinating. We were dealing with real paranoia about sketches." Here are the crossroads that separate theater and filmmaking. Allen was hoping for the authentic in the research. Sketches represented a broad theatrical and romantic reinterpretation of the era rather than an accurate portrayal that he sought from Loquasto.

The costume designer also uses the costume illustration to sell their concept to the producer and the star. Credited with more than one hundred motion-picture titles, Helen Rose designed in service of the story and the studio. She said, "I have nothing to sell but the product on the screen; if I'm not sold on it myself, I wouldn't think of trying to sell it to a producer or a star. I say very little when people come in to look at sketches. I do very little talking. I don't try to force fashions down people's throats. And if somebody comes in with a good idea, I'll accept it." When a designer and director fail to reach an immediate mutual understanding about the design for the character, the prognosis is poor that the producer or the star will be happy. There is every possibility for this miscommunication to expand exponentially into an insurmountable production problem, and the designer may be fired as collateral damage. A designer supplies an abun-

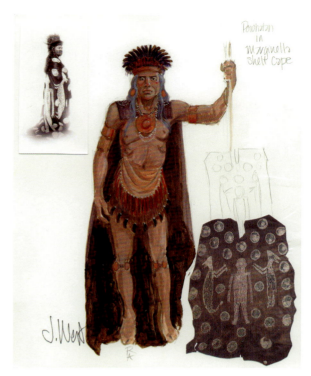

Costume designer: Jacqueline West.
Costume illustrator: Richard La Motte.
The New World, 2005.

dance of versions of the same costume for any director, producer, or actor who requires an alternative choice or choices. Multitudes of sketches are often created for one dress, and sketches are often redone to obtain a unanimous approval.

Happily, directors and designers who survive the gauntlet of film production may establish a long collaborative union based on trust. They can look forward to a much more relaxed relationship on the next cooperative project. Over the past ten years, it has become increasingly expected for a designer to bring sketches, artwork, and ideas into a first job interview with a director. Sometimes, this meeting is the first contact that a designer has with a director. The risks of misstepping are many. Based solely on the reading of a screenplay, the designer may be in total sync with the director's vision or may get it all wrong. When Jacqueline West knew that she was scheduled for an interview for *The New World* (2005) with Terrence Malick, she "started doing research and drawings. When I went to the meeting, I put some sketches and vivid historic Native American references down on the table for him. They had a dark, mysterious quality, which was in alignment with what Terry had in mind." West got the job and wound up also designing for Malick's subsequent feature, *The Tree of Life* (2011). From that first auspicious interview, the two have now established a flourishing creative partnership that enriches Malick's stories on film.

SKETCH TO SCREEN

Following an introductory phone conversation with the actor, the first meeting of the costume designer and actor may be nerve-racking. In the scheme of film production, it is also likely that the director and the costume designer have been discussing the character and the screenplay for many weeks, if not months, of preproduction. Honored at a Costume Designers Guild Gala, Dustin Hoffman said that by the time an actor arrives in the fitting room, the costume designer has been thinking about the character for months and knows that person very well. Typically, actors will see a sketch only after the director approves the design. Actors

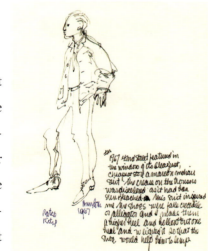

Costume designer and illustrator:
Ann Roth. *Midnight Cowboy*, 1969.

may be cast late and may arrive from another production only days before shooting. It is a moment of extreme vulnerability. Ultimately, the actor must fill the shoes of the character. Actors walk into the fitting room wondering how to become that individual. It is in this fragile moment that they see the sketch for the first time. When the director has discussed the script in depth with the actor prior to the first fitting, the

designer can be more assured of a successful result. In 1954, Helen Rose explained the need for conclusive agreement about who the character is and what they look like. Rose said, "The biggest problem for a designer for the screen is getting the director, the producer, and the star together. Many times they all have a different opinion. We always have a meeting and keep talking until somebody gives. That way a producer can't throw a design out during the picture and say he's never seen it. We throw few clothes out." Getting everyone in the room is the best way to guarantee a happy ending.

The fitting process is filled with land mines. The director and producer may have approved the sketch, but this is no assurance that the actor will be happy with the costume. The costume designer can be put in a no-win situation when stuck in the middle of a power struggle. During the shooting of *Manpower* (1941), Milo Anderson wrote, "Yesterday we had considerable upset with Miss [Marlene] Dietrich while trying on her gowns. After executive producer Hal Wallis had OK'd her changes, when the time came to shoot the scene, Dietrich refused to wear the wardrobe. The sketches had been OK'd by Mr. Wallis, but then Dietrich changed the gowns so they were not made up to look like the sketches. Miss Dietrich has an idea that she is to be dressed like a clothes horse stepping out of *Vogue*, rather than the wife of a railroad lineman who makes $200 a month and could never afford to buy her the clothes that Dietrich wants to wear in this picture." Wallis and Dietrich should have come to an agreement about the character long before the costumes were designed and created by Milo Anderson. Unfortunately, this kind of miscommunication is not uncommon, and nightmares like this one are repeated in film production even now.

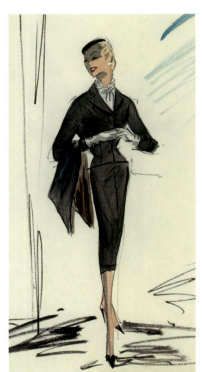

Costume designer: Edith Head. Costume illustrator: Grace Sprague. *Vertigo*, 1958.

Designers today will be reassured to know that they are not the first ones to deal with the warring factions of the studio executives, producers, directors, and actors. Disagreements about costuming create high anxiety and decimate already impossibly tight production schedules, wreaking havoc with relationships, costume budgets, and designer's reputations. During the preproduction of Alfred Hitchcock's *Vertigo* (1958), Edith Head remembered Kim Novak "saying that she would wear any color except gray, and she must have thought that would give me full rein. Either she hadn't read the script or she had and wanted me to think she hadn't." In a classic example of Head's genius working with actors, she kept her cool and negotiated as Alfred Hitchcock's representative in the fitting room. Head continued, "I explained to Kim that Hitch paints a picture in his films, that color is as important to him as it is to any artist. As soon as she left, I was on the phone to Hitch, asking if that damn suit had to be gray, and he explained to me that the simple gray suit and plain hairstyle were very important and represented the character's view of herself in the first half of the film. The character would go through a psychologi-

cal change in the second half of the film and would then wear more colorful clothes to reflect the change. 'Handle it, Edith,' I remember Hitch saying. 'I don't care what she wears as long as it's a gray suit.'"

As a director who planned his films from exquisitely drawn storyboards, it's too bad Hitchcock hadn't made this point as clear to Novak prior to her first fitting. Head was prepared when Novak returned for the second fitting, ready for battle. "I had several swatches of gray fabric in various shades, textures, and weights. Before she had an opportunity to complain, I showed her the sketch and the fabrics and suggested that she choose the fabric she thought would be best on her. She immediately had a positive feeling and felt that we were designing together. Of course, I knew that any of the fabrics would work well for the suit silhouette I had designed, so I didn't care which one she chose." Mr. Hitchcock got his gray suit, and Head overcame what could have become an incendiary situation with her usual aplomb. Janet Leigh followed Eva Marie Saint as the next "Hitchcock blonde." Leigh and Head were fast friends and close collaborators from the start, and there were no missteps. They worked together on five films. Leigh said, "Edith would sketch right in front of me. We would discuss the character. She wanted to know how I was approaching the character so that she could think of things through my eyes, as well, and my interpretation of the role."

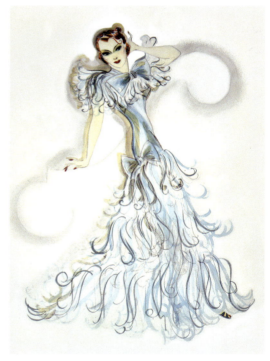

Costume designer and illustrator: Bernard Newman. *Top Hat*, 1935.

Most actors relish the opportunity to improvise in the fitting room. This was as true in the Golden Age of Hollywood as it is in the twenty-first century—actors enjoy the opportunity to play with clothes. For *Top Hat* (1935), the iconic Fred Astaire and Ginger Rogers musical, Rogers collaborated closely with designer Bernard Newman on her costumes. Her daytime ensembles were appropriate for the character she was playing, and Rogers's dance gowns had to meet the criteria for her athletic dance numbers. Interestingly, Ginger Rogers rehearsed in trousers. Rogers recalled, "Bernard Newman met with me to discuss the colors and shapes of the various dresses I was to wear in the film. Unlike a lot of designers, Bernie was open to suggestions. He'd say, 'Tell me what kind of dress do you want to wear and what color would you like?' Then he'd show me swatches of all sorts of beautiful materials. Bernie sketched as I spoke. It's funny to be discussing color when you're making a black-and-white film, but the tone had to be harmonious. Bernie's final sketch had an extremely low back, as I had requested. The watercolor that he had used was just the color blue that I wanted. The dress was form-fitting satin encircled by ostrich feathers, lots of feathers."

In 2002, master designer Albert Wolsky had a richly rewarding creative experience working with Jude Law in the period drama *Road to Perdition* without using sketches as a starting point. Often, clothes provide actors a shortcut to immediately capture the role. Wolsky remembered, "I could do things on Jude

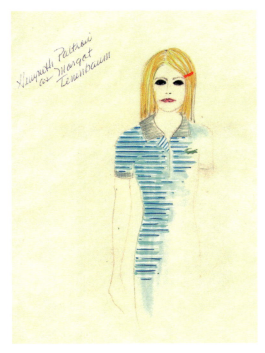

Costume designer and illustrator: Karen Patch. *The Royal Tenenbaums*, 2001.

that I couldn't do on any other actor. I started with all real clothes to get some sort of a shape and get an idea of what to do. Sketches are wonderful, but the body has to wear it. Jude wanted his pants too short. His shoes were barely held together they were so old." With a parallel theater career on the West End and Broadway stage, Jude Law employs costume as a vehicle to explore each of his many characters. Wolsky finds his creative path by building character from the inside out using real garments. Costume designer Jenny Beavan feels the same way, saying, "I don't draw. I have no interest. I mean, I have lovely costume drawings—the ones that keep appearing in some paper are done from the still photographs by someone. I was told that I needed costume drawings. I said, 'If you really want to pay for them, up to you.' And somebody's done quite nice drawings, but that's what they are, nice drawings, they're nothing to do with my work. But it's that organic process; it's rather us becoming Sherlock Holmes."

Contemporary costumes complicate a designer's job, as everyone is an "expert" in modern clothing. Sometimes, it takes longer to fine-tune a character to everyone's satisfaction. In the modern film, it's quite common for everyone, including cast, crew, and studio executives, to have an opinion. For James Brooks's *As Good as It Gets* (1997), designer Molly Maginnis groaned, "Jim Brooks (who I adore) told me repeatedly that this was 'the most important costume in the movie.' I did about thirty sketches to try to accommodate the line [in the script] that Jack Nicholson says to Helen Hunt, 'Why do I have to wear a jacket, when you're in a housedress?' Hunt's dress had the look of an ordinary housedress while the character, Carol Connelly, felt glamorous wearing it. After designing director Wes Anderson's first two films, designer Karen Patch reminisced, "Wes Anderson has become more and more involved and interested in using costume as a tool to develop the characters. . . . He'll say, 'Well, I saw this locket . . .' It can be the smallest detail. I keep a notebook and keep adding ideas as he calls me. I do a lot of sketching, but Wes does, too. I would send him sketches, and then he would send back a sketch . . . basically, a drawing in one continuous line, like an outline. He'll say, 'I think maybe the lapel is wider'; we're talking buttons here in terms of how specific. By the time I get the script, we've pretty much fleshed out all the characters." It is a gift for designers to work with a director who understands and values costume, and it is rare that a director can discuss clothes with a designer in such detail.

Designers have always had to fight for period pictures to stay in the "period" in which the story is taking place and not have the clothes creep toward popular current fashion. For one hundred years, the cornerstone of Hollywood studio marketing has been that the audience will not accept people in the story who don't resemble themselves. This meshing of current fashion and period costuming has hamstrung generations of dedicated costume designers. Ultimately, the studio, the producer, and the director have the last word on the

look of any era. Historic research rarely trumps the popular conceptions of beauty in any film, and this decision helps define the entertainment business: to please the audience. During the 1940s, in the heyday of the movie musical, Irene Sharaff was brought to MGM to design for the storied producer Arthur Freed. Sharaff complained about her new job in Hollywood: "Realism in movies then was unreal. A star playing a secretary of modest financial means changed her dress and matching accessories for every scene. My own attempt at period realism in *Meet Me in St. Louis* (1944), set in 1903, dismayed the producer at first. When he saw my costume sketches, his pained remark was, 'How can you have a star with no cleavage?'" Sharaff's high-necked, heavy cotton lace gown for Mary Astor was one of the many pleasures of that wonderful film. Defending design decisions to the studio, producers,

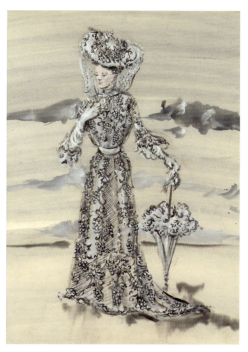

Costume designer and illustrator: Irene Sharaff. *Meet Me in St. Louis*, 1944.

directors, and actors is not a modern dilemma. Adrian said, "I remember being particularly amused one day after having shown Garbo a sketch and taken a great deal of pains to explain why I had designed it for a certain scene, the colors, materials, and various other reasons for its being used. During all this time, Garbo had remained completely silent but interested. After I thought I had convinced her, she just said, 'Yes.' And then, with a look of surprise, she said, 'Garbo talks!' and laughed gaily." Although they were longtime friends and professional partners, Adrian's reaction to Garbo's silence is fraught with anxiety and even panic that betrays his experience with less accommodating actresses. Garbo's laughter brought him great relief in the fitting room.

A costume fitting may occur anywhere convenient: in a room adjacent to the costume workroom, at the studio, at a costume rental house, in a hotel room, on location in a ladies' room, in a Winnebago, or at the actor's home. At the first costume fitting, a full set of measurements is taken by the cutter-fitter. Many designers assemble a rack filled with sample garments that can be tried on by the actor to establish a shape and silhouette for the character. Attaching sample fabric swatches to the sketch is another way for the designer to express their thoughts about texture and color. Swatches help the drawing take on a three-dimensional meaning and allow the director and the actor to touch the costume before it is made.

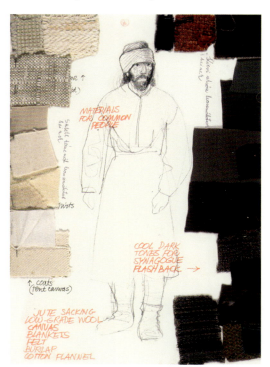

Costume designer and illustrator: Dorothy Jeakins. *The Fixer*, 1968.

The best first fittings are a mix of experimental theater and playful improvisation in front of a three-way mirror. In private, the actor and the costume designer must establish a rapport and an intimacy; trust

is paramount. The fitting room is an incubator for the creation of a new being. The cutter-fitter is also included in the first fitting and in every subsequent fitting until the costume is complete. Warner Brother's workroom head Catena Passalacqua remembers, "When I went for a fitting, I'd like to have the sketch and the right fabric in the dressing room so that the actor could get into the mood." The sketch is in view, often placed on the ground, leaning on the mirror and facing the actor so that it stays in view during the entire fitting. The presence of the character suffuses the fitting room.

The path that the finished costume sketch takes from the fitting room to the costume workroom is a very short one. After the first fitting, the sketch is placed next to the cutting table. The character drawings for an entire production, including principal and secondary characters, may be posted—or the entire wardrobe, including every change for one principal character may be on view. Costume assignments are commonly distributed throughout a workroom (or several workrooms), with different seamstresses being assigned individual characters. In large costume houses and workrooms, the costume sketch owns the pride of place within close view of the cutting table. Thumbtacked, pinned, taped, or unceremoniously nailed onto a wall, the costume illustration lives next to the cutter-fitter as a constant point of reference as long as the costume is being draped, cut, trimmed, and fitted on the actor. It will remain on the wall until the final costume is approved.

This drawing is not handled tentatively or gingerly as a work of fine art. There is no protective cover, frame, or glass to keep it pristine. The drawing will collect and survive fingerprints, coffee cup rings, and numerous thumbtacks. The role of the sketch has now moved from the realtor's model-home sales pitch to the blueprint from which the contractor will build the house. Like architectural drawings, the sketch is also used to create a budget for the manufacturing of the costume. In close consultation with the designer, the cutter-fitter determines the type, weave, finish, and quantity of fabric to be used in the costume, along with the amount of trim, lining, buttons, buckles, zippers, and thread needed to fully realize the drawing. Each item required for the creation of the costume is listed and totaled. Added to those costs can be specialty embroidery, pleating, embellishments, beading, and fabric dying and aging. Costs will again be multiplied by the number of garments needed for every scene and combined with the labor costs associated with their production in a union or nonunion shop. The costume illustration will inform all of these decisions and will be integral in determining the price of each custom-made costume.

In the studio era, the costume department chief signed off on every production's costume budget. The back of many a costume illustration from Hollywood's Golden Age carries the signature or initials of these executives on a budget stamp. Helen Rose explains that "at MGM every sketch had to be signed by the director, producer, head of the art department, the color consultant, and the head of budget. As a result, a beautiful sketch was often completely destroyed with a mixture of signatures." On modern films, although the costume supervisor, cutter-fitter, and the costume designer share the responsibility to produce economical garments, the costume supervisor manages the overall costume budget with the agreement of the costume designer and under the supervision of the unit production manager and the producer. It is the costume designer who decides how the budget will be used for what is ultimately needed to tell the story.

There is an unspoken understanding between the costume designer and the cutter-fitter that the final costume will look like the sketch. This will be more than a resemblance; the costume must match the proportion, cut, and detail of the drawing. As they drape, pattern makers constantly compare the scale and proportion of the garment, their eyes darting between the drawing and the dress form. The waist, shoulder, and hip must resonate with the illustration. Incredibly, the toile must fully capture the spirit of the design and be evocative of the character. A form specifically made to the measurements of the actor will hold the first rough muslins through the finished costume.

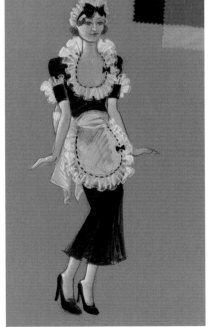

Costume designer: Deboroh Nadoolman. Costume illustrator: Kelly Kimball. *Oscar*, 1991.

Although they work hard to match the three-dimensional pattern to the two-dimensional sketch, even the most innovative cutter-fitters are constrained by the costume designer's sovereignty and their choices. Costume construction is affected by myriad variables. Sometime in their careers, designers can make mistakes in taste and in construction. Bad choices happen to the best designers. There are also budgetary limitations that impact materials—whether the fabric will be polyester or silk may be more than a character-based decision; one fabric may be cheaper. In addition, costume designers work in an art of illusion. A brightly patterned fabric may look better on screen than in person, and often designers choose to use the reverse side of a patterned fabric when a costume calls for a naturalistic faded effect. Experience will dictate the choices of pattern and texture for every costume. All fabric will photograph differently than it appears in the shop, and the costume designer must know the difference.

Unwelcome surprises also happen in the costume workroom, where a designer may find a miniskirt on the dress form when the sketch clearly shows a maxi. During the production of *Oscar* (1991), I strode confidently into Sylvia's, a small successful costume house in Hollywood, with a terrific sketch of Nora (Joycelyn O'Brien) under my arm. *Oscar* is an early-1930s farce with the character of Nora as the wisecracking Irish maid. She had one costume change. The simple, narrow, long-skirted, organza-aproned

ensemble was based on Jean Harlow's back-talking ladies' maid in *Dinner at Eight* (1933). It was unmistakably 1931—vertical, ankle-grazing fashion. Kelly Kimball captured the look in the drawing. Days later, the stiff black silk for the uniform and sheer white organza fabric for the apron arrived, and I reviewed the design with the cutter. One week later, I arrived at Sylvia's to find a fluffy black micro-miniskirt with enormous ruffled puff sleeves waiting for me on the dress form; a cliché of a comic French maid. All that was missing was the fishnet stockings and the heels. The cutter had no explanation for disregarding the sketch except that she was "helping me improve"

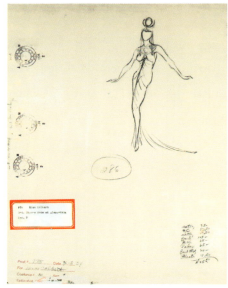

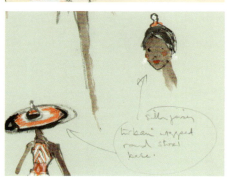

what she determined was a serious error in my judgment. She found nothing about the sketch funny. I made it clear that she was to make the costume that I designed. These miscommunications can be terrifying for a designer trying to survive in a stressful business with little time and less budget. Sylvia's remade the costume with no charge to the production and Nora's look on screen was a double of the sketch.

Designers are only as talented as the cutter-fitters who interpret and then improve upon their ideas in the costume illustration. This is not a secret. Costume designers in the very beginning of Hollywood forged the same enduring relationships. In 1925, MGM costume designer Cora MacGeachy described costume designing in an article called "American Girl Able Designer," for the *Los Angeles Times*: "Everything I put into a sketch of a costume can be duplicated in materials by the modiste [dressmaker]. Miss [Sophie] Wachner has executed my designs faithfully and with great artistry, and I am deeply grateful for her work." The relationship with the cutter-fitter could be described as the costume designer's key collaborative relationship.

Many designers have been known to create loose freestyle sketches that strike terror into the heart of their costume workrooms. These may indicate a style, a silhouette, the germ of an idea of a dress. The cutter-fitters are the interpreters of the designer's intent. Many times, these artisans will recommend where the seams, the buttons, and the zippers should land and which fabric (of a thousand choices) will drape to the best advantage based on nothing more than pencil scratches. These are the people that determine how best to bring the spirit of the sketch and the vision of the designer into three dimensions. Masters of proportion and fit with endless remedies for imperfect bodies, it is the cutter and the tailor who define a designer's career. Without the very best cutter-fitter, the designer will never be the very best costume designer.

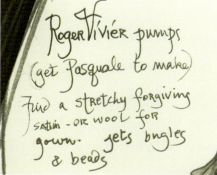
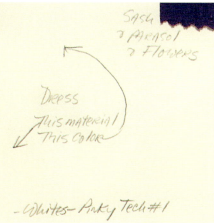

Drawings are often creatively defaced during conversations at the cutting table, when designers and cutters armed with pencils revise and refine the first design. These disjointed notes and marks are evident on sketches throughout this book. The rich collaboration between the cutter-fitter and the designer can lead to an explosion of ideas. The rear view of a gown, side panel, brim of a hat, shoes, and collar of a costume are often penciled in a corner or on the back of the drawing. The shape of a hat may be lovingly transcribed in words and pictures on the drawing after a worktable conversation with the milliner.

Designer Julie Weiss writes veritable novels on her drawings. "A number of these sketches say 'over' on the bottom, because on the back of the sketch comes the [written] clarification," Weiss explains. "Maybe the skirt has cartridge pleating? Maybe the skirt is gathered? Maybe the third layer of the skirt is an old curtain?" All of this detail may not be clear from the sketch and would need a detail drawing for explanation. The personality of the designer also abides in those surface scratches surrounding the character study. Arrows, circles, and stars shout, "Look at me," to the cutter. An absence of scribble may indicate the sketch was considered too precious to disfigure, or that it was created after the fact—in the calm of postproduction. The designer's penciled jabbering becomes an intrinsic part of a sketch. Notes plead for everything that the designer missed (or sense they missed) in the drawing. They billboard reminders to the cutter-fitter or tailor: "Don't forget the pearl buttons!" or "The lace trim is exactly like this!"

The costume sketch will take yet another star turn in the dressing room during the final fitting. At the final fitting, the contract between the actor, the costume designer, and the cutter-fitter is complete. This is the moment of final approval. That's no guarantee that it will be picture perfect. Costume designer Earl Luick told this story about a time in the 1930s when "Edward Stevenson, who designed for RKO, submitted some sketches to Irene Dunne. She loved them. The gowns were fitted. Gorgeous. On the first day of shooting, she refused to wear them. 'I have my own clothes

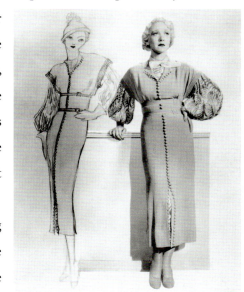

Actress Helen Twelvetrees. Costume designer and ilustrator: Travis Banton.

here. I'll use them. The studio can reimburse me.'" This is not the only time in the history of costuming that an actor, director, or producer has had second thoughts about an "approved" sketch. And not the only time when an actress has had a tantrum and refused to wear a dress that has been fit multiple times and approved by everyone. Costume design is a nerve-wracking business.

When the costume resembles the approved sketch, the designer has made good on the promise to the director and the producer. With the completion of the hair and makeup design, the actor has transformed into the character, and with luck and hard work by the creative team, the complete portrait of the character in the drawing has been realized. Now the life of the post-fitting- and post-cutting-table costume illustration becomes tentative and tenuous. The costume has been fitted on the actor and established in a scene. Before the production has wrapped, the costume has already been set aside. This is the danger point in the life of a drawing. It has become redundant.

DEATH OF A SKETCH

The tension between the art of cinema and the movie business has entered its second century. It is a long and deeply held conviction in the film industry that the only thing that counts is the future. The scene shot today is ancient history; tomorrow's call sheet, postproduction, the opening weekend receipts at the box office, the DVD sell-through, digital downloads, and the development of the next blockbuster follow in rapid succession. By the time the costumes are wrapped and sent to storage at the studio or costume house or sold on eBay, the costume designer is on holiday, working on another project, or on the unemployment line. The director has moved in with the editor and post-

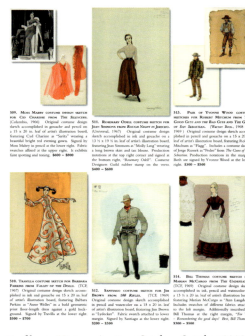

Profiles in History Auction Catalog, October 2009.

production team to begin the assembly of scenes and to create a compelling story out of the millions of custom-designed rectangular frames that will be the movie. This is when the marketing machine cranks up, and the directors, producers, and executives begin their war over creative control of the film.

Ultimately, it is most desirable for the director to be the final arbiter of what characters or scenes make it into the final film. If the action is slowed by a parade of zombies, a million-dollar special effect in outer space, or a costumed ball in the palace of Versailles, for example, that scene or effect will be cut, and costumes created for that sequence will never be seen by the film's audience. Film production is filled with specialists and department heads that make their artistic contribution but who have no control about how the film will work together as a whole. It is up to the director to piece together the scenes to tell a dynamic story. Storytelling must be efficient. Although costume designers may mourn the loss of their work in deleted characters and scenes, movies are made in the cutting room. Collaborating intimately with Paul Verhoeven on four films,

costume designer Ellen Mirojnick sought to anticipate the director. "*Basic Instinct* (1992) was of a particular genre, and what I love to do with Paul in conversation is to figure out the overall feeling of the movie that he wants to achieve—beyond what's written in the script," Mirojnick said. "Then there are the characters, the palette, the textures, and the specific dramatic points and structure that need to be achieved. We'll always discuss specifics, and I will suggest ideas by a physical representation, whether it be the sketch, the fabric, or a sample garment."

Subplots, characters, and entire storylines may also be cut prior to or during shooting, which may leave many costume drawings unfinished. Many costume sketches are prepared for films that are canceled in preproduction and others for characters that are later dropped during revisions of the screenplay. Script revisions are commonplace with pink, green, blue, and yellow pages arriving in rapid succession and sometimes throughout shooting. It is rare that a script is shot as a first draft. Elaborate costumes may be completed, rejected at the last minute, and then replaced by others in the final version of the movie. It is common to find sketches of clothing from scenes that were never shot. There is also a wealth of sketches from a selection of choices prepared by the costume designer for the director and actor where just one was chosen. Entire character wardrobes may have been drawn and the film never shot. Theadora Van Runkle designed and manufactured a complete wardrobe for a secondary female character, the wife of Tom Hagen (Robert Duvall) in *The Godfather: Part II* (1974). The part was cast and scenes shot; however, the actress's entire role was cut from the final film. Unrealized costumes of costume designers and costume illustrators are also represented in this book because they represent one part of the production process. These drawings were created with the same research and consideration as their realized cousins.

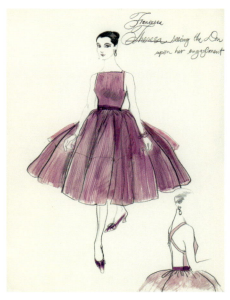

Costume designer and illustrator: Theadora Van Runkle. *The Godfather: Part II*, 1974.

Hollywood is an industry built on insecurity and reinvention. On the set of *Papillon* (1973), Dustin Hoffman remembered Steve McQueen (the biggest movie star at the time) saying, "When I look in the rearview mirror, I see Robert Redford coming up behind me." Matinee idols fade; today's blonde bombshells and red carpet celebrities are quickly replaced; sets are recycled, and the physical remnants of a film are considered industrial waste. The sale of production art and costumes is another way to offset losses. Few studios (now smaller enterprises that are part of multinational corporations) have the ability to maintain archives. Some, like Warner Bros., have sought to monetize recent blockbusters, such as the Harry Potter franchise, with traveling exhibitions, theme parks, and studio tours. This trend has been an unlikely boon to film preservation and asset recovery.

It is no surprise to the motion picture community that, with a century of filmmaking behind us, no major Hollywood museum exists. The past is of no value to film producers or to multinational corporations; nothing is as important as the opening weekend's box office. This disrespect for the past (cut your losses and move on) was just as true during the Golden Age, when Eastern banks, investors, and film

exhibitors owned the studios. And it is true today, when every artist on every film works for the shareholders of the multinationals who own the studios. Old studio product was finally recycled on television, then in art houses and revival theaters, like the Vanguard in Los Angeles and at the Thalia in New York. Old movies could then be seen on VHS, laser discs, DVD, Turner Classic Movies, and now streaming on Netflix.

During the height of Hollywood production, when the studios were releasing forty to sixty features a year, costume departments, designers, and illustrators were producing costumes at an unprecedented rate. Until the late 1940s, most costume designers were contract artists working within large studio costume departments. During the Golden Age a chief designer ran the department; Howard Greer (Paramount), Travis Banton (Paramount), Edith Head (Paramount, Universal), Walter Plunkett (RKO), Charles LeMaire (20th Century Fox), Orry-Kelly (Warner Bros.), Adrian (MGM), and Irene Lentz Gibbons (MGM) all held this position at some point in their illustrious careers. Beneath these chief designers worked a coterie of designers, assistant designers, illustrators, and a legion of tailors and dressmakers. Helen Rose designed multiple pictures at the same time, a common practice in that era for a contract designer. Usually this meant that she was responsible for designing the star players when she began production on the three scheduled 20th Century Fox war-time musicals *Coney Island* (1943), *Hello, Frisco, Hello* (1943), and the Lena Horne vehicle *Stormy Weather* (1943), for which, she remembered, "Dozens of sketches were required, not only for the leads, but for the cast." Rose had "a big job to finish all by myself in just a few months. I never took off my hat, and had I not been sketching, I probably would have worn my gloves, maybe even my kid gloves." Rose exaggerated a little as she was assisted in this task by sketch artists who helped her produce the artwork required for these concurrent projects. The sheer number of films churned out by the Hollywood studios during this era intensified the ephemerality of each film—and its artifacts. There were so many sketches, drawn at such a phenomenal rate, that soon the costume shops had real storage issues.

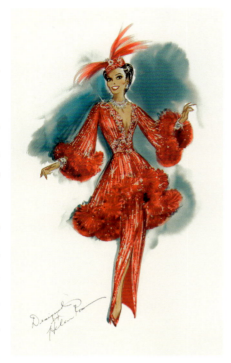

Costume designer: Helen Rose. Costume illustrator: Donna Peterson. *Stormy Weather*, 1943.

At the Warner Bros. studio workroom where Catena Passalacqua started her career as a seamstress in 1964, she remembers that the designers "just gave [sketches] to you and then they walked away. The movie's finished and the sketches were on my little board and they would just stay there. One would be behind the other sketches that they'd given you." Then they were piled on top of one another and either thrown away or, according to Catena, costume department chief Jack Delaney used to throw them into a cupboard. Later, as Warner Bros. workroom chief herself, Passalacqua witnessed the destruction of the vast costume stock. She said, "[The studio] wanted to get rid of clothes. And I had to fight to keep them. Don't sell them, and don't let the next designer rent the gown and cut the train off, or cut the back out for the next show." Passalacqua was

a rare and ardent advocate for keeping the costumes intact in the hostile pre-archive era. "There were quite a few pieces I used to lock up, and my assistant had the key and backed me up. Now [Warner Bros.] has a wonderful museum with these clothes." She laments with the understatement that in the last gasp of the studio era, "Things were really not well done."

Every movie required costumes, and in the case of a studio like Warner Bros., these designs were sketched, manufactured, fitted, and filmed all on the large studio lot in Burbank. Upon completion of production, the costumes were inventoried and placed among thousands of others in costume stock, available for immediate reuse and rental. With the exception of a few drawings that were given as gifts to actors, framed on the studio or costume department wall, or kept as fond mementos by ladies in the workroom, sketches piled up in closets and storage rooms never to be looked at again. Considering that other major studios, including Paramount, MGM, Universal, Columbia Pictures, 20th Century Fox, and RKO, employed the same type of costume-assembly-line practice, the number of sketches produced each year during the Golden Age of Hollywood is staggering.

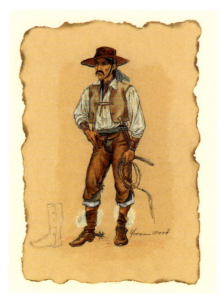

Costume designer and illustrator: Yvonne Wood. *Guns for San Sebastian*, 1968.

Private collector Tom Culver spent time as a professional costumer working in costume departments and on film productions during the last gasp of the studio era. "The sketches were the property of the studios, but people would leave them because they didn't want to cart them around," he says. When Culver asked his close friend costume designer Yvonne Wood about the whereabouts of her drawings, she said, "Tom, we had so much stuff. I would go from sketching at RKO, and then I'd go over to Fox and sketch for Helen Rose because she was too busy; we were all over the place, and nobody kept them. They [the sketches] were just a map." There was a seemingly endless supply of drawings. It is unimaginable that the quantity of finished watercolor drawings made it possible for studio and costume house employees to casually and routinely cut costume illustrations into squares and use them as telephone scratch paper—but this is true. Culver was working at Western Costume, where "sketches were cut in thirds and used as dividers on hangers." Early on he recognized the value of the work: he was looking for a costume one day, and saw one-third of a sketch of a costume for Olivia de Havilland and cried, "My God, isn't that a shame? We'll never see that picture again. This is art and nobody cares."

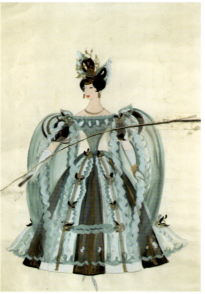

Costume designer and illustrator: Mary Kay Dodson. Front and back of sketch. Unidentified film.

Longtime collector and film buff Bill Sutton remembers Debbie Reynolds telling him that "she went to a fitting at Western Costume, and in the fitting room there was a chair whose missing fourth leg was a tall stack of costume designs." If it was standard practice to cut sketches into clothing rack dividers, they were also used as doormats in poor weather (there is a lovely sketch at Los Angeles County Museum of Art with a clear footprint across the center), as insulation lining the walls of a windy workroom, or to plug a leak in a wet ceiling. As detritus, one relic of the costume process, the drawings were more highly prized for their value as kindling than as artwork.

Larry McQueen is a noted archivist with deep roots in Hollywood history; his private costume collection is internationally renowned. McQueen remembers the final days of the studio costume departments in the late 1960s and 1970s, saying, "It was paper . . . and they [the studios] had rooms full of it. So why not use it? They were taking stuff out of MGM and [using it] as landfill for the San Diego Freeway. It's absolutely criminal. They had no idea what they had. [Costume designer] Donfeld told me that there was a room at MGM with an enormously high ceiling that was nothing but sketches. Don remembered that the man in charge said to him, 'If there's anything you love, just take it,' and Don said, 'Why would I take it? It's always going to be here.'" That sentiment perfectly expressed the feeling held as sacrosanct by the costume community. The giant costume shops, with their delicious stores of archival fabrics and button boxes, hats, corsets and accessories, boxes of silk flowers and Swiss ribbons from factories that long ago went out of business, rack upon rack of period wardrobe from decades of filmmaking, would always be there exactly as we left it—in Culver City or in Burbank. It is breathtaking to think that it is all gone.

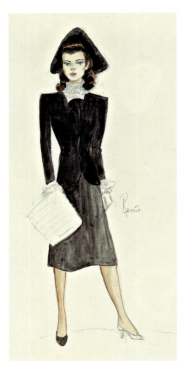

Costume designer and illustrator: Renié. *Kitty Foyle*, 1940.

In 1970, MGM sold masses of costumes, props, and other movie miscellany at a highly publicized auction. Edward Maeder, curator of the 1986 exhibition "Hollywood and History" at the Los Angeles County Museum of Art, and chief curator of costumes and textiles for LACMA from 1979 to 1992, assembled the rich collection of costumes and illustrations at the museum. Maeder said, "Before the MGM auction, LACMA (the textile and costume department) was invited to 'help itself' to anything they wanted for 'free.' With thousands of drawings to choose from, the LACMA curator took only one sketch of significance, the suit that was worn by Ginger Rogers in *Kitty Foyle* (1940), designed by Renié Conley." In total, a mere five costume design illustrations were deemed worthy of the museum curator. The sheer number available at the time diminished the perceived value of the individual illustrations. "At a dinner party in Beverly Hills one evening," Maeder remembered, "I was speaking with the family who had organized the famous MGM auctions. Their original plan was to try to match the costume sketches with

the actual costumes, as they thought this would attract collectors. They were sadly mistaken; few of the purchasers were interested in the sketches. They told me that literally 'truckloads' of them were sent to the landfill upon which the Century Plaza Hotel was subsequently built."

Eddie Marks, president of Western Costume, is a veteran of the motion picture business and of that venerable century old institution. The 1980s were an exciting time for costuming in a rapidly changing industry. According to Marks, when he started as a costumer at the iconic Western building on Melrose Avenue, "There was a place [in the building] called the Flood Control, where there were mountains and mountains of sketches. It was above the fur room, kind of like a mezzanine floor and not a place where costumers went. There was sports equipment thrown up there, too. At the time, I didn't realize how valuable these [sketches] were and how wrong it was for them to be put there." With a name like Flood Control over the fur room, it's fair to surmise that these sketches were providing insurance that the valuable furs would stay dry in a California winter deluge.

Marks had a storied career as a costumer on many studio films. His early days in the late 1960s and early 1970s were spent at MGM: "Back in those days, there were sketches all around and through the administrative offices in frames. They were also tacked up on the wall along a huge board that [the MGM workroom] had on the third floor, which had the production number of every movie MGM had made, with the title of the movie and the costume designer's name. It was probably twenty feet long, and each of these cardboard labels was about one inch high and maybe eight or ten inches long. I'm sure that in the 1970s after the sale [the famous MGM 1970 auction] they probably just tore it down. It was a total masterpiece of an archive." Production numbers can be found penciled into the corner of many Golden Age costume sketches, but with no master key or inventory, the possibility of identifying any one sketch is slim.

At the moment of the great unraveling, which could be placed at the time of the tragic (for Hollywood history) 1970 MGM and then 1971 20th Century Fox auctions, the studio costume departments hemorrhaged archival material and studio property. Grand fraud and petty larceny lost their meaning in an upside-down world where "saving" a costume or costume sketch meant stealing it. There were a few notorious "Robin Hoods" who stole to protect the life of a sketch or costume or to resell them. These wily costumers' reputations suffered among their professional colleagues from a wide perception of their greed. That studios did not care about their storehouses of historic clothing and original artwork was an open secret. These were objects that held a value less than zero—they cost the studio overhead. Vast numbers of artwork perished (like the film stills, negatives, and the movies themselves) in the dumpsters of the day. The most colorful and decorative

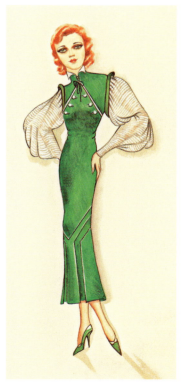

Costume designer and illustrator: Orry-Kelly. Unidentified film.

drawings survived because costume designers, costumers, and seamstresses recognized their intrinsic worth and took them home to safeguard and to hang on their walls.

Sketches of the greatest Hollywood stars in their most iconic roles exist because of their celebrity and notoriety. Tom Culver recalls that he was working in costume stock at Paramount when his "chair hit something and I thought, 'What's that crackling?' I looked down, and there was the Elizabeth Taylor sketch from *A Place in the Sun* (1951) rolled up on the floor. It had been there for at least ten years. They would probably vacuum around it." He was shocked by the revelation of this celebrated strapless Edith Head creation (that launched a thousand prom dresses) under his feet. After Culver gathered his wits, he pounced, "This is ridiculous." He asked, "Can I have this?" And they said, "Sure, it's just going to end up in the garbage." Larry McQueen remembers, "So much of the stuff walked out of the studio. And did it walk out with the blessing of the studio? Yes."

Christian Esquevin adds, "It was reported that Adrian had given Greta Garbo all of his designs for her at one time. And that she was going to have a whole room decorated in nothing but his costume sketches." But finding Adrian sketches turns out to be a lifelong treasure hunt for Esquivin. Garbo's estate yielded little, and the mystery of the lost cache of Adrian sketches continues. He designed for the greatest stars— Garbo, Joan Crawford, Jean Harlow, Norma Shearer, and Katharine Hepburn—in some of the most memorable movies of the era; thus the lack of Adrian's drawings to support this unique legacy is a mystery. The dearth of Adrian sketches has spawned its own mythology. Larry McQueen remembers, "Someone told me that at MGM, when Irene [Lentz Gibbons] came in as costume department director in 1942, that she destroyed Adrian's sketches. I don't know if she didn't like Adrian or if it was just that she replaced him." If this is true, this nasty practice at MGM seemed to be contagious. Collector Tom Culver repeated hearsay that "when Irene left MGM, Helen Rose took her sketches out in big boxes and threw them in the trash." Sketches from designer colleagues have also emerged in the personal collections of Golden Age designers like Edith Head and Walter Plunkett. The Academy of Motion Arts and Sciences' Margaret Herrick Library and the Wisconsin Center for Film and Theater Research received Edith Head's sketch collection, which included those of many of her contemporaries. Esquevin explains, "Occasionally, the Golden Age designers kept a few, but there's certainly no exhaustive record of any one designer's output."

Incredibly, thousands of costume illustrations did survive the institutionalized neglect, Flood Control, and the Century City and freeway landfill. Many of these drawings were adopted into good homes and private collections upon the dismantling of the MGM and studio costume departments. Today, the archive collections of Warner Bros. and Universal Studios contain a wealth of unpublished drawings that remain in the studios' possession. Studio archivists like Warner Bros. chief Leith Adams exercise a discretionary budget to purchase studio material, costumes, and illustrations at auction. In the late 1960s and early 1970s, there were a handful of collectors who understood that costume sketches were valuable artifacts in their own right. Costume sketches were regularly discovered at estate sales, swap meets, and flea markets for a token sum.

Embedded in this artwork, for those who care to decipher the hieroglyphics, is information about production budgets, studio protocols, and working practices throughout Hollywood history. For the film and costume scholar, illustrations offer a bounty of historical riches.

AFTERLIFE

Signatures of any kind are relatively rare on costume designs. The designer sometimes autographed illustrations if they had achieved some status (Walter Plunkett, for example) or were gifting the drawing to an actress or cutter-fitter. Promotional genius Edith Head signed many of "her" sketches as part of her branding strategy. Head drew almost none of her "original" signed sketches, much to the confusion of people who have bought them at auction thinking they were drawn by her personally. During his long retirement, Walter Plunkett repainted many of his most famous designs in great detail. Although he didn't mean to deceive the public, auction houses sell many of these costume illustrations, most notably from *Gone With the Wind*, as "original." They are authentic, but were not created at the time for the film; it was more likely that they were created to pay Plunkett's mortgage. More often, costume illustrations, created in a hurry for film productions, went unsigned by their creators. There was no reason to sign a sketch. Sketches were never produced to be preserved or to be framed; they could always do or commission another one if necessary. The designer certainly did not expect the drawing to be kept pristine in a studio archive.

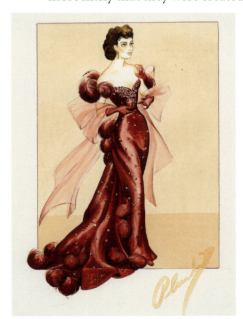 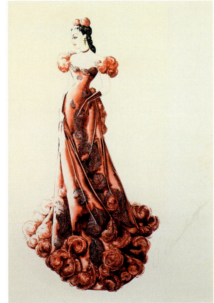

Costume designer and illustrator: Walter Plunkett. *Gone With the Wind*, 1939.
LEFT: Reproduction of his own work. RIGHT: Original sketch.

Costume illustrators were rarely given the opportunity to sign drawings. A notable exception was Adele Balkan, drawing for designer Charles LeMaire at 20th Century Fox Studios. She remembered, "No, you had no recognition whatsoever. You were hired as a sketch artist, and you just did sketches. But I doubt very much that the designer ever showed a sketch that he or she hadn't had some input. It was a give and take there for quite a while. But the star didn't want to know that the assistant had designed it or the sketch artist had done it; they wanted to think the designer had done it, naturally. And so did the head honchos. They wanted the designer who was hired to do it to do it. No one cared who did the sketch as long as the designer did the design." Occasionally, illustrator's initials are found, perhaps coyly tickling the toes of an actress at the bottom of an image, an "RR" for Robin

Costume designer: Colleen Atwood. Costume illustrator: Robin Richesson. *Beloved*, 1998.

Richesson, for example, illustrating for designers Colleen Atwood or Joanna Johnston, or "TVR" for Theadora Van Runkle, illustrating for Dorothy Jeakins. Thankfully, a cultural shift has revised this practice, and the bottom of the page now often proudly announces the signatures of both the illustrator and the designer.

Throughout Hollywood history, costume designers have signed sketches of their costumes illustrated by other people, and this was accepted practice. Professional illustrators have existed from the beginning of the movies. Although it could be argued that a designer's signature is preferable to no signature at all, the convention of designers signing sketches drawn by illustrators has created an attribution nightmare—and massive confusion among collectors and costume and film historians. Illustrators were, and are, part-time employees and freelance artists. They are rarely credited in film end titles or listed on film department rosters. The question of who drew any anonymous costume illustration remains a conundrum to be solved by future costume design scholars. Golden Age designers such as Edith Head, Helen Rose, Jean Louis, and others employed multiple costume illustrators (and often shared the same freelance sketch artists), confounding the collector and the most scrupulous costume archaeologist. Designers were not perpetrating a hoax or a swindle; they were just trying to get the dress design into the workroom, manufactured, and onto the actress as quickly as possible. Finished, custom-made costumes rarely had designer labels sewn on the inside of garments other than "MGM" or "Paramount," with the actor's name written in ink below. Drawings presented a costume designer with the opportunity to take possessory creative credit, and Rose, Louis, Head, and others branded their work with giant signatures across hundreds of costume illustrations mostly painted by other people.

Head's biographer, David Chierichetti, explained, "Edith had a lot of ideas of her own, but because of the volume of work, she relied a lot on her sketch artists. She would say to her sketch artists, 'Give me some collars for a woman's blouse.' And the sketch artist would make up a whole bunch of sketches, and Edith would find one or two that were interesting and incorporate them into the sketch that was done for the whole outfit." To save time, Head asked her sketch team to produce croquis. This shortcut, commonly used in the fashion business, of a multitude of little identical basic figures, remains useful for the busy designer. Designer Earl Luick describes Head's process for Audrey Hepburn's dresses in *Sabrina* (1954), saying, "Grace Sprague, her sketch artist, prepares dozens of likenesses of the pert little actress, which Edie

calls 'Little Audreys.' After Sprague has clothed them all, she will seek approval from Edie and her chief assistant designer, Pat Barto." Undoubtedly, Head made changes to the design, and Sprague went on to complete a final drawing for production and approvals.

Head's ruse to get her first job at Paramount has now become Hollywood legend. Talented and ambitious, she was never afraid to bend the rules to her advantage. In his 1951 memoir, *Designing Male*, former Paramount costume director Howard Greer describes in detail Miss Head's audacity. She "appeared for her interview with a carpetbag of sketches. The next morning, she appeared for work looking frightened, 'I have the most awful confession to make! You see when I was faced with my first interview I was suddenly seized with panic! I was afraid that if I didn't have a lot of wonderful sketches I'd never get the job!' I said, 'But they *were* wonderful. All of them!' She cried, 'That's just it! They weren't any of them mine! I just went through the art school where I've been studying and picked up everybody's sketches I could lay my hands on!' She might easily have saved her breath and her confession, for her own talents soon proved she was more than worthy of the job. Her name was Edith Head, and she's now head designer of Paramount's wardrobe and an annual collector of Oscars for her screen clothes."

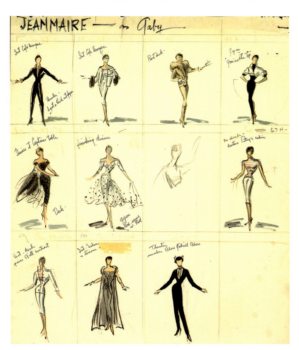

Costume designer: Edith Head. Costume illustrator: Grace Sprague. *Anything Goes*, 1956.

Head said about Greer and Travis Banton, her later boss, "I would sketch in their style, and I would more or less become indoctrinated to that type of designing." Head's lack of illustration skill never hurt her career or undermined her confidence. Catena Passalacqua recalls being at the cutting table when "Edith came by and made stick figures on paper and said, 'You put the sleeve here.' That was it. I was so sorry that I didn't save that piece of paper."

From the time she started at Paramount in the 1920s to her "second chapter" at Universal in the 1960s, Edith Head kept her costume illustrators close. Head never hesitated to put a pencil to the off-the-cuff thumbnail sketch at the cutting table or in conversation with an actress. But for production and for formal sketches, she took no chances with presentation. She wanted her designs to be understood, admired, and approved. Head appreciated that fine artists could showcase her ideas best. These illustrators, many of them distinguished motion picture costume designers in their own right, included: Adele Balkan, Waldo Angelo, Pat Barto, Grace Sprague, Donna Petersen, Leah Rhodes, Renié Conley, Marilyn Sotto, Rudi Gernreich, Richard Hopper, and Bob Mackie, among others. Although none of these illustrators shared a signature with Head, their work is mostly identifiable by their own style and the decade in which it was produced. In fact, when the sketches are grouped by drawing style, the author of the piece emerges.

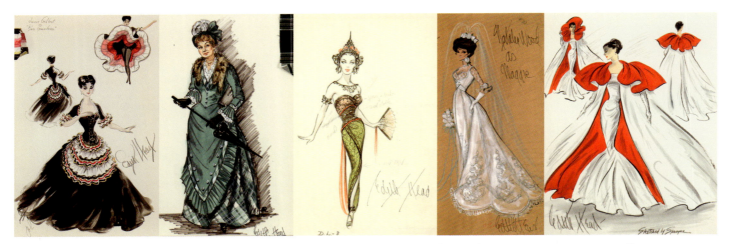

These costumes designed by Edith Head. FAR LEFT: Costume illustrator: unidentified. *Red Garters*, 1954. LEFT: Costume illustrator: Bob Mackie. *The Matchmaker*, 1958. MIDDLE: Costume illustrator: John L. Jensen. *Road to Bali*, 1952. RIGHT: Costume illustrator: Pat Barto. *The Great Race*, 1965. FAR RIGHT: Costume illustrator: Grace Sprague. *Lucy Gallant*, 1955.

Marilyn Sotto was one of the many artists working for Edith Head on *The Ten Commandments* (1956). It is not a surprise that today hundreds of "Edith Head"–signed sketches remain unattributed to an illustrator. Sotto remembers, "*The Ten Commandments* had five designers: Dorothy Jeakins, Edith Head, Arnold Friberg did the concept painting, John Jensen designed the armor, and Ralph Jester. I started sketching for actors Yul Brynner and Charlton Heston. On *The Ten Commandments,* I did between three hundred and four hundred drawings and a lot of throwaways. I designed a lot of the smaller parts, like Jethro and Jethro's daughters." It was typical for a huge number of sketches to be produced for the "sword and sandal" epics and musicals of the 1950s. Designers were under pressure to get the go-ahead from the producer and director before they put costumes into production in time for the commencement of shooting.

There are other significant issues that compound the problem of identifying sketches. Edith Head took her show on the road. A true marketing genius, Head used her celebrity to host fashion shows based on re-creations of her most famous designs. Notoriously, she also commissioned re-creations of the sketches from her illustrators, so that many variations of the same iconic dress now exist in multiple collections. The original sketch of Elizabeth Taylor from *A Place in the Sun* that Tom Culver found under his chair at Paramount wardrobe is one outstanding example of Head's messy inheritance. For one costume, there may be three, five, or a dozen documented copies extant.

Which sketch is the "original"? Each sketch was hand-drawn by an artist working with Miss Head from her design. The "working drawing"—the sketch from which the costume was actually made, the one that was pinned to the cutter's cork board— is the most desirable. This is the drawing that may be marked with marginalia and stamps, approvals and scene numbers, corrections, accessories, and a possible scratch-out and revision. This drawing will resemble the style of the decade in which it was created, not the following one or two. It may be battered, but it is an

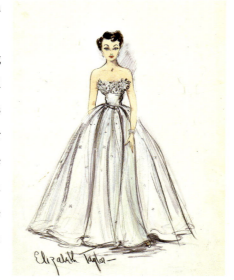

Costume designer: Edith Head. Costume illustrator: Donna Kline. *A Place in the Sun*, 1951.